DRAWING LEGENDARY
MONSTERS

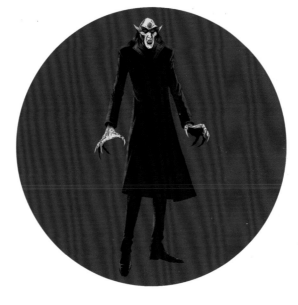

STEVE BEAUMONT

ARCTURUS

CONTENTS

REPTILIANS

DEMI-HUMANS

UNEARTHLY BEASTS

ARCTURUS

This edition published in 2010
by Arcturus Publishing Limited
26/27 Bickels Yard,
151–153 Bermondsey Street,
London SE1 3HA

ISBN: 978-1-84837-494-2
CH000700EN

Author and illustrator: Steve Beaumont
Designer: Steve Flight
Editor: Fiona Tulloch
Cover designer: Peter Ridley

Printed in Singapore

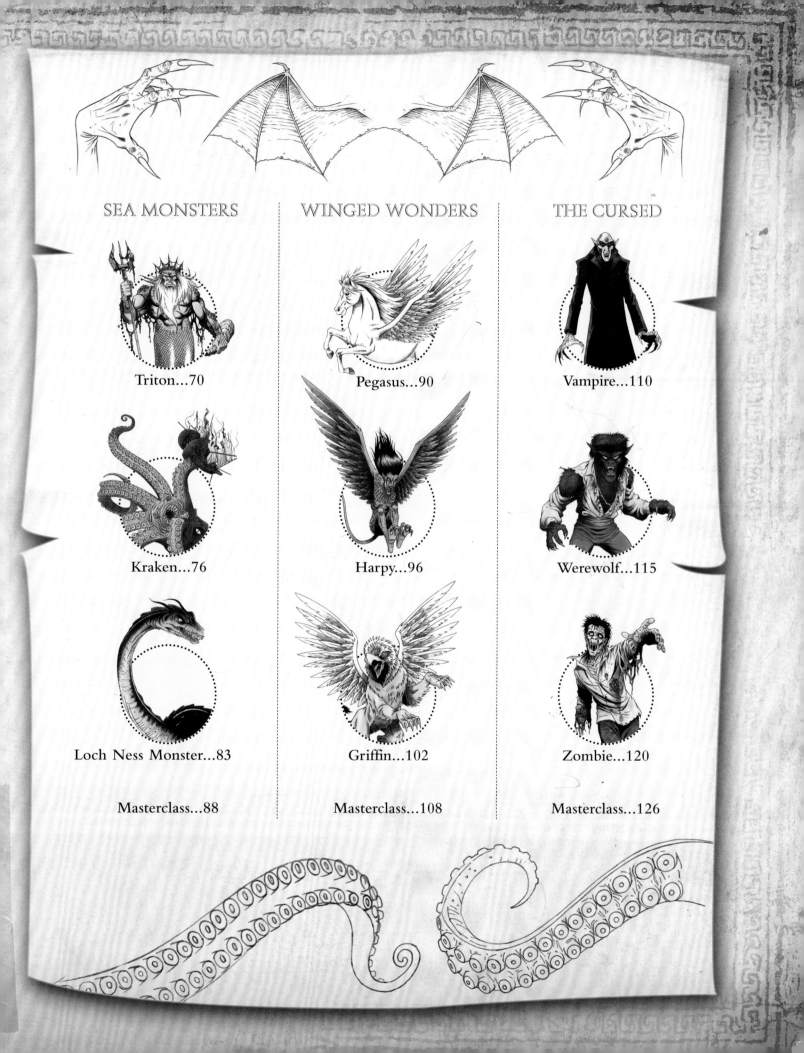

INTRODUCTION

Do you ever watch movies, play video games or read comic books featuring fantastic and bizarre creatures? Have you ever wished you could draw creatures like these yourself, with confidence and flair? Well you can, and this book will show how. All you need is a little practice.

Inside, you'll discover many of the world's most famous mythological beasts. There are incredible sea monsters such as the Kraken, giant winged animals including Pegasus and the Harpy, and really scary stuff like vampires, zombies and werewolves.

The best part of all is that you don't have to be an amazing artist. You just need to possess the desire to learn. So, sharpen those pencils and have fun with this assortment of crazy creatures. By the time you have worked your way through them all, we're sure you'll feel inspired to go off and create some magical beasts of your own.

USING THE BOOK
Step-by-step exercises
There are step-by-step drawings for each creature with clear and simple instructions. Use these to build up your pictures and develop your artistic talent.

Masterclass
At the end of each section, you'll find a masterclass lesson. This will show you how to refine your drawings and add professional detail.

Top tips
Look out for the top tips scattered throughout the book. They'll give you extra hints on how to improve your style.

GETTING STARTED

Before you can start creating fantastic artwork, you need some basic equipment. Take a look at this guide to help you get started.

PAPER
Layout Paper
It's a good idea to buy inexpensive plain A4 or A3 paper from a stationery shop for all of your practice work. Most professional illustrators use cheaper paper for basic layouts and practice sketches, before producing their final artworks on more costly material.

Cartridge Paper
This is heavy-duty, high-quality drawing paper, ideal for your final drawings. You don't have to buy the most expensive brand – most art or craft shops will stock their own brand or a student range. Unless you're thinking of turning professional, this will do just fine.

Watercolour Paper
This paper is made from 100 per cent cotton, so it is much higher quality than wood-based paper. Most art shops stock a large range of weights and sizes. Either 250 grams per square metre (gsm) or 300 gsm will be fine.

PENCILS
Buy a variety of graphite (lead) pencils ranging from soft (6B) to hard (2H). Hard pencils last longer and leave less lead on the paper. Soft pencils leave more lead and wear down quickly. 2H pencils are a good medium option to start with. Spend time drawing with each pencil and get used to its qualities.

Another product to try is the mechanical pencil, where you click the lead down the barrel using the button at the top. Try 0.5mm lead thickness to start with. These pencils are good for fine detail work.

CIRCLE TEMPLATE
This is useful for drawing small circles.

FRENCH CURVES
These are available in several shapes and sizes, and are useful for drawing curves.

INKING AND COLOURING

Once you have finished your pencil drawing, you need to add ink and colour. Here are some tools you can use to achieve different results.

PENS

There are plenty of high quality pens on the market these days that will do a decent job of inking. It's important to experiment with a range of different ones to decide which you find the most comfortable to work with.

You may find you end up using a combination of pens to produce your finished artworks. Remember to use a pen with watertight ink if you want to colour your illustrations with a watercolour or ink wash. It's usually a good idea to use watertight ink anyway as there's nothing worse than having your nicely inked drawing ruined by an accidental drop of water!

PANTONE MARKERS

These are versatile, double-ended pens that give solid, bright colours. You can use them as normal marker pens or with a brush and a little water like a watercolour pen.

BRUSHES

Some artists like to use a fine brush for inking linework. This takes a bit more practice and patience to master, but the results can be very satisfying. If you want to try your hand at brushwork, you should invest in some high quality sable brushes.

WATERCOLOURS AND GOUACHE

Most art stores stock a wide range of these products from professional to student quality.

DRAWING USING SHAPES

All the artworks in this book are created using the 'shape method'. This is a technique practised by many professional artists.

Always start with a basic stick frame. Then build up your drawings using a mixture of 3D shapes, commonly cuboids, balls and cyclinders. Don't rush – the secret to creating life-like work is to give your drawings 3D form from the start.

Look at the example below of the Werewolf taken from pages 115-119. The drawing is broken down into a group of manageable shapes (pictures 1 and 2) – an oval for the head, cylinders for the arms and legs and box shapes for the body.

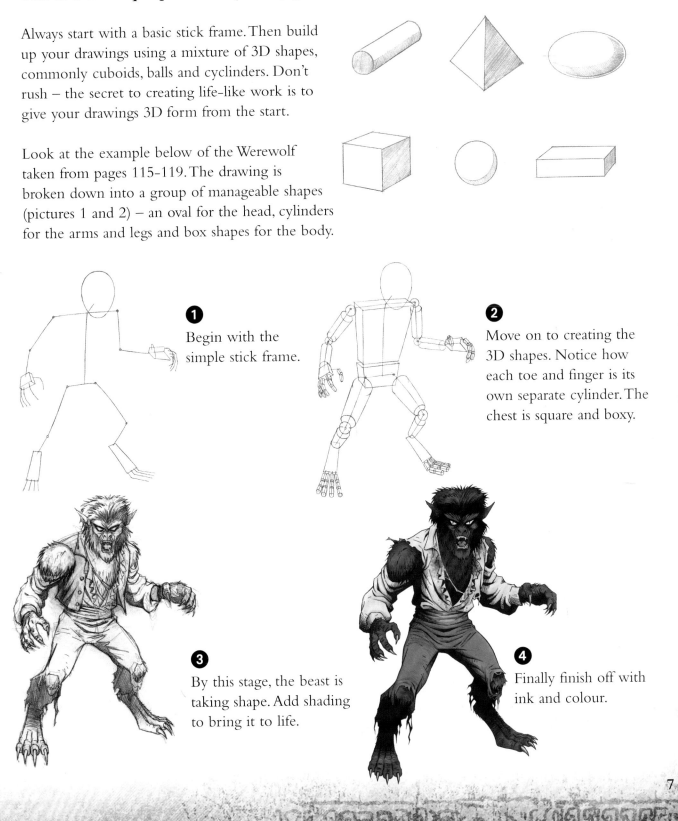

❶ Begin with the simple stick frame.

❷ Move on to creating the 3D shapes. Notice how each toe and finger is its own separate cylinder. The chest is square and boxy.

❸ By this stage, the beast is taking shape. Add shading to bring it to life.

❹ Finally finish off with ink and colour.

DRAWING HANDS

Here is a detailed breakdown of how to construct a hand. It's not as diffficult as you might imagine.

Picture 1 Draw a square shape for the palm and circles for the knuckles. From the knuckles, construct the fingers using small thin cylinder shapes. If you look at your own hand, you'll see you have two joints and three sections on each finger. Your thumb has one joint and two sections. Draw a triangle to represent the area that joins the thumb to the palm.

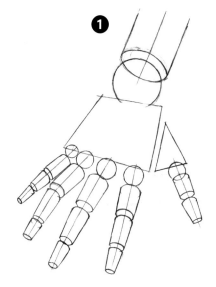

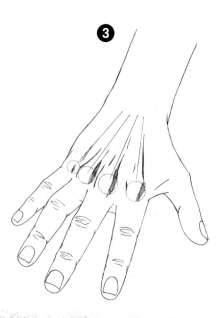

Picture 2 Next give the hand an outline to create the skin. Then draw the tendons that run along the back of the hand. Look at your own hand again as a guide. Don't forget to add the fingernails.

Picture 3 Erase the construction lines and add wrinkles to the skin where the finger joints are. Join up the circles on the knuckles with the tendons. Give the skin flexibility by adding bend lines around the thumb.

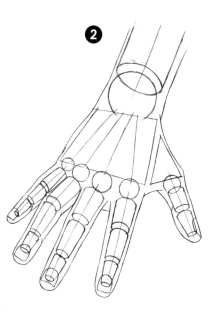

USING INK

This section shows you how to ink your drawings with confidence and skill, and will make sure that they grab the attention.

Picture 1 Look at this finished pencil sketch of a vampire's head. The pencil detail needs inking over.

Picture 2 The eyes are a good place to start. Notice how we have made the eye outlines vary in thickness. This useful technique allows you to suggest where your light source is coming from. In this drawing, the light is coming from above, so we've made the line weight thinner at the top, to suggest more light, and thicker at the bottom, to suggest shadow.

Picture 3 The main features of the face are now inked. All that is left to do is to ink in the shading and the lines of the skin. Notice how by darkening around the eyes, we have given the face more impact.

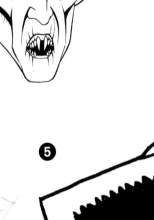

Picture 4 This shows an alternative method of inking which is not as detailed as the previous example but still produces a strong effect.

Picture 5 The solid black area of the vampire's jacket is created by inked zigzags. Notice how the effect is not on every line but it is used just enough to give an interesting edge to a large block of ink.

SHADOWS AND HIGHLIGHTS

Most legendary monsters are night-time creatures, so the settings you draw them in need to be dark. But as the creatures themselves tend to be dark, you will need a device to create contrast for the figures. This will help them to stand out and stop them from disappearing into the background.

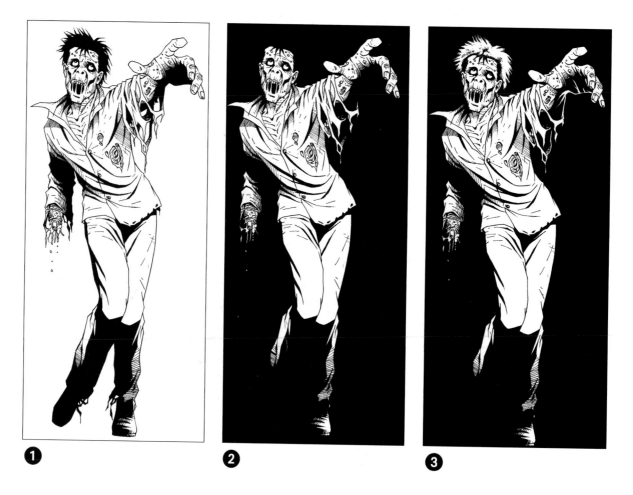

1 **2** **3**

ZOMBIE FRIGHT

In **Picture 1**, you can see an inked zombie figure. It has enough bold lines and solid black areas to make it stand out from the white background even though it is essentially a white image.

In **Picture 2**, the background has been inked solid black. Notice how this is an extremely effective way of throwing out the white areas of the zombie drawing and giving the figure impact. The dark hair is lost but as dark hair is difficult to see in darkness, this is okay and a style often used by many professional artists today.

Picture 3 shows that by adding white highlights, you can make the hair visible again if you wish.

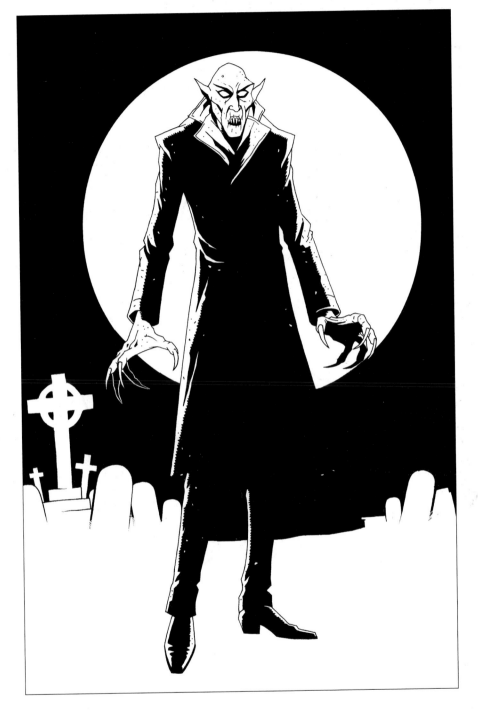

MOODY VAMPIRE

Remember the vampire we drew earlier? He was almost solid black. If we were to
place him in a night-time setting, he would hardly be seen. So we have added a full moon
and the outline of a cemetry for the background. The moon not only creates a light area
for him to stand out against but also frames the subject and makes him a point of focus.
This simple trick is commonly used in fanatasy art and comic book drawing.

COLOURING

Every artist has their favourite choice of materials when it comes to colouring their work. The drawings in this book were coloured using inks and marker pens. By experimenting with different materials, such as pencils, water colours, gouache and oil paints, you'll discover your own preferred method. The steps on these two pages should work fine if you are using marker pens, water colours or gouache.

❶

To colour this dragon, start with a beige or pale-sand base to create a fleshy skin tone. Use pale grey or brick white for the horns and claws.

❷

Next apply darker sand tones over the base colour. Make sure the top colour is reasonably strong compared to the base colour so that if you choose to leave highlights, the base colour will show through. Use a dusky or dull orange for the upper skin rather than a bright orange.

❸

Add mid–grey tones to accentuate the horns and use a bright yellow base for the fire flaming out of the dragon's mouth. Apply darker orange and red to accentuate the dragon's skin.

❹

Add darker greys to build up the overall tone and shading. Then finish off with warm mid to dark grey to give depth to the skin colour and definition to the body, horns and claws.

REPTILIANS

Slithering scales and powerful eyes are the trademarks of the reptilians. A **Dragon**, from the Greek 'drakon' meaning 'serpent', was an enormous, formidable beast. Despite its huge wings and fiery breath, however, the title of 'king of serpents' belongs to the **Basilisk**. It was the largest snake the world has ever known, and had a ferocious cockerel's head. A glare from its piercing eyes was fatal. Another creature with a deadly stare was **Medusa**. Anything she looked upon instantly turned to stone. Her hair of writhing snakes marks her as a 'gorgon', the Grecian female reptiles of whom Medusa was the only mortal.

DRAGON

1

Start with the stick figure. Draw an S-shaped body and lines for the wings. You also need a circle for the head and two cuboids for the mouth.

2

Add the rest of the construction shapes, using cylinders for the neck, body and tail. Draw wider shapes for the thicker end of the tail and neck, and narrower shapes for the tail end and where the neck joins the head.

3

Improve the head and add the skin by drawing around the shapes. At this stage you can also add the claws.

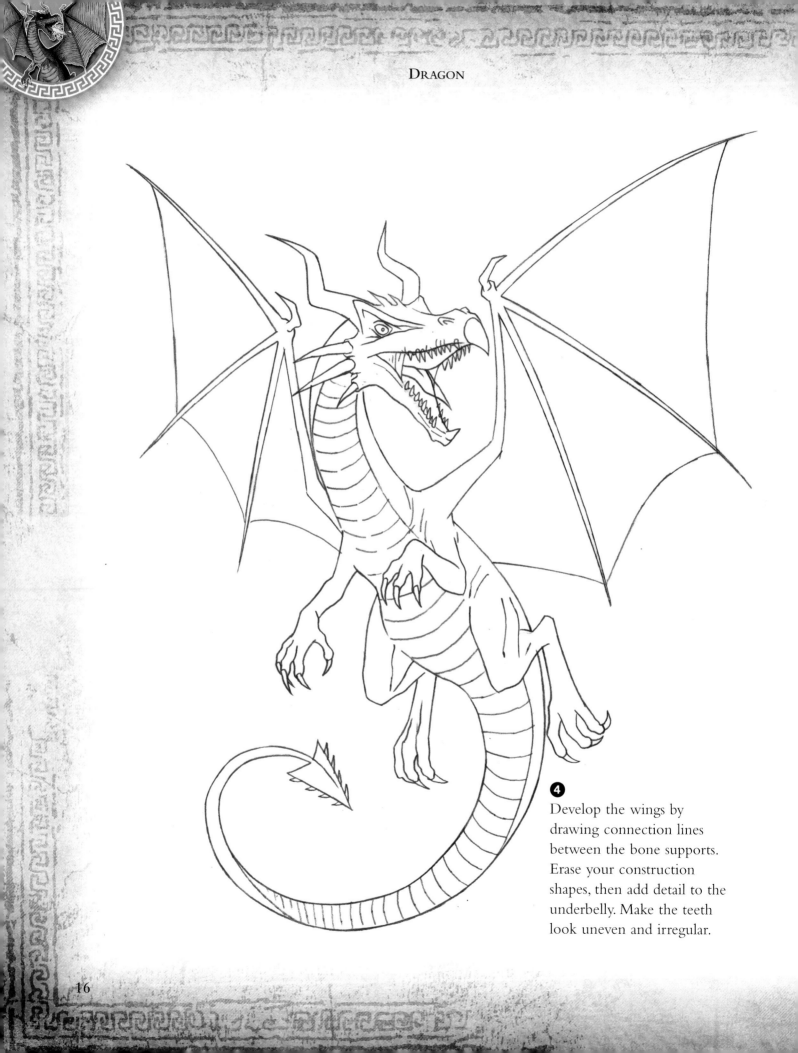

4 Develop the wings by drawing connection lines between the bone supports. Erase your construction shapes, then add detail to the underbelly. Make the teeth look uneven and irregular.

Check out page 33 for tips on how to draw a dragon's wings.

5

Clean up the drawing and add detail to the skin and the wings. Try to create a torn, papery effect at the wing edges. Don't forget to include the fire coming out of the dragon's mouth.

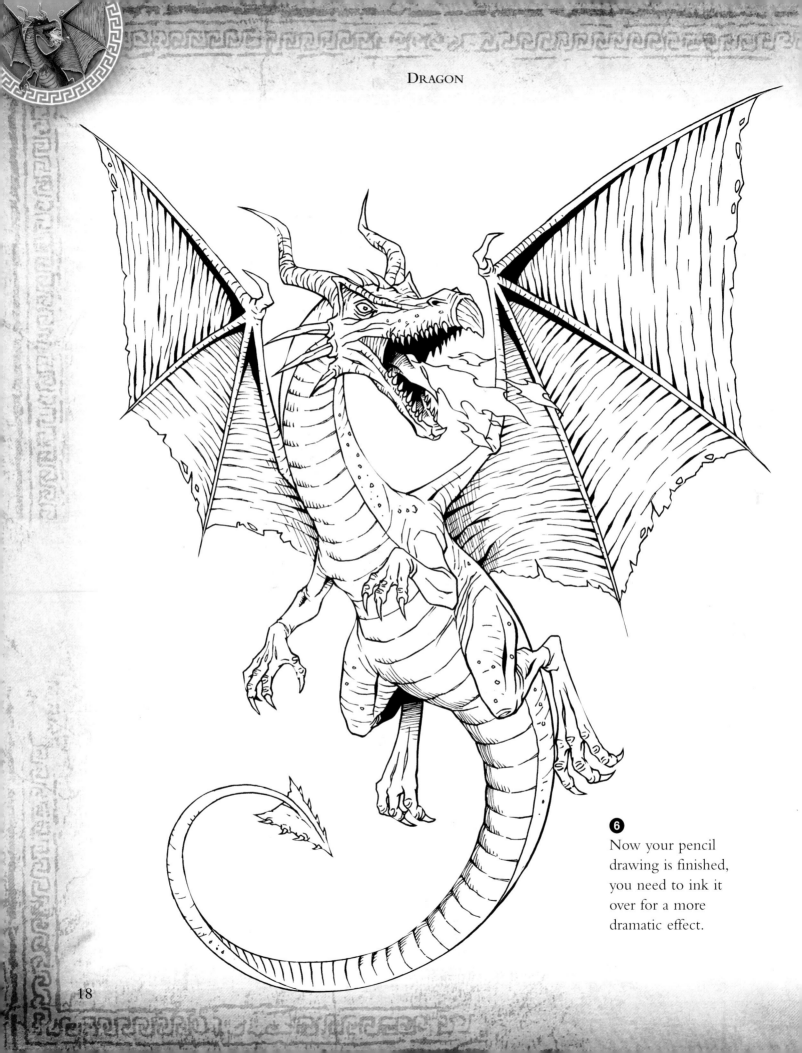

6
Now your pencil drawing is finished, you need to ink it over for a more dramatic effect.

7

Bring your dragon to life by adding colour. Start by applying a beige base to the whole drawing.

Build up layers using a sandy colour followed by grey on the belly and underside of the neck and wings.

For the upper body, use orange and dirty red. You can create dirty red by mixing red with a little grey.

BASILISK

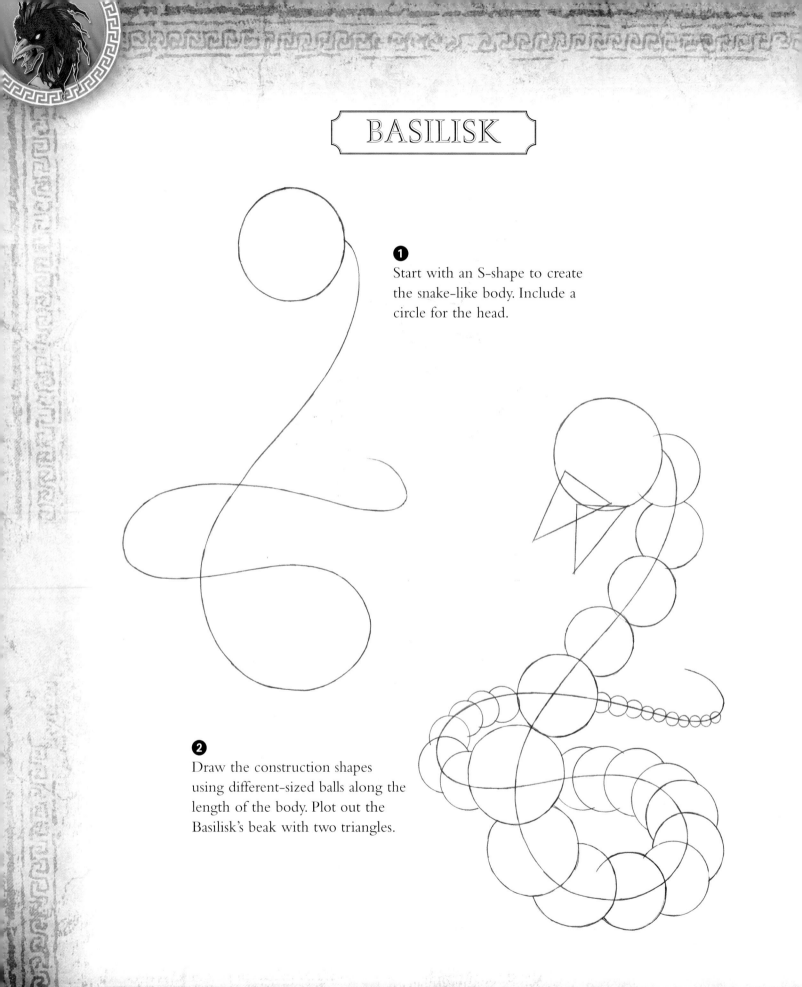

1

Start with an S-shape to create the snake-like body. Include a circle for the head.

2

Draw the construction shapes using different-sized balls along the length of the body. Plot out the Basilisk's beak with two triangles.

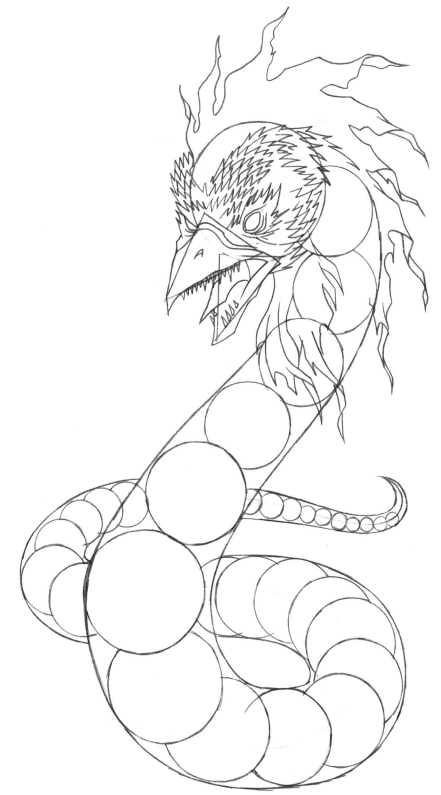

3

Create a smooth form over the shapes by adding the skin. Then draw the ferocious head. In mythology, the Basilisk has the head of a cockerel with sharp teeth, demonic eyes and a wild crest.

4

Remove the construction shapes and add lines for the belly. Draw the outer scales using the brick method to create a scaly, snake-like skin.

The brick method for creating scales is described on page 32.

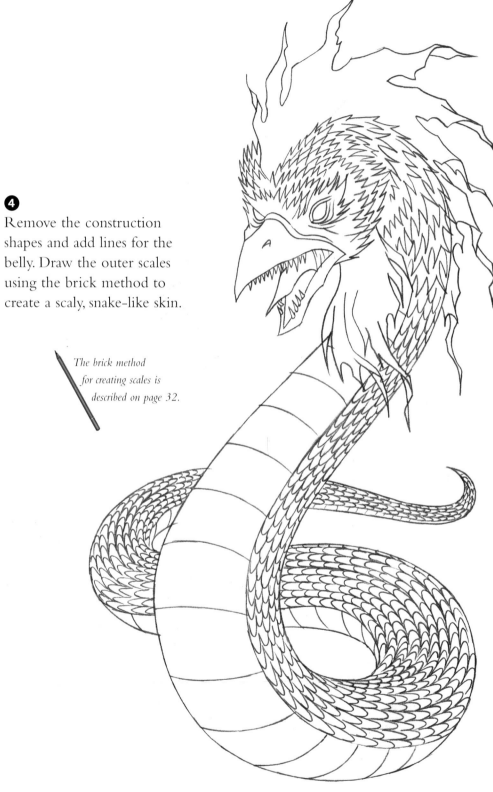

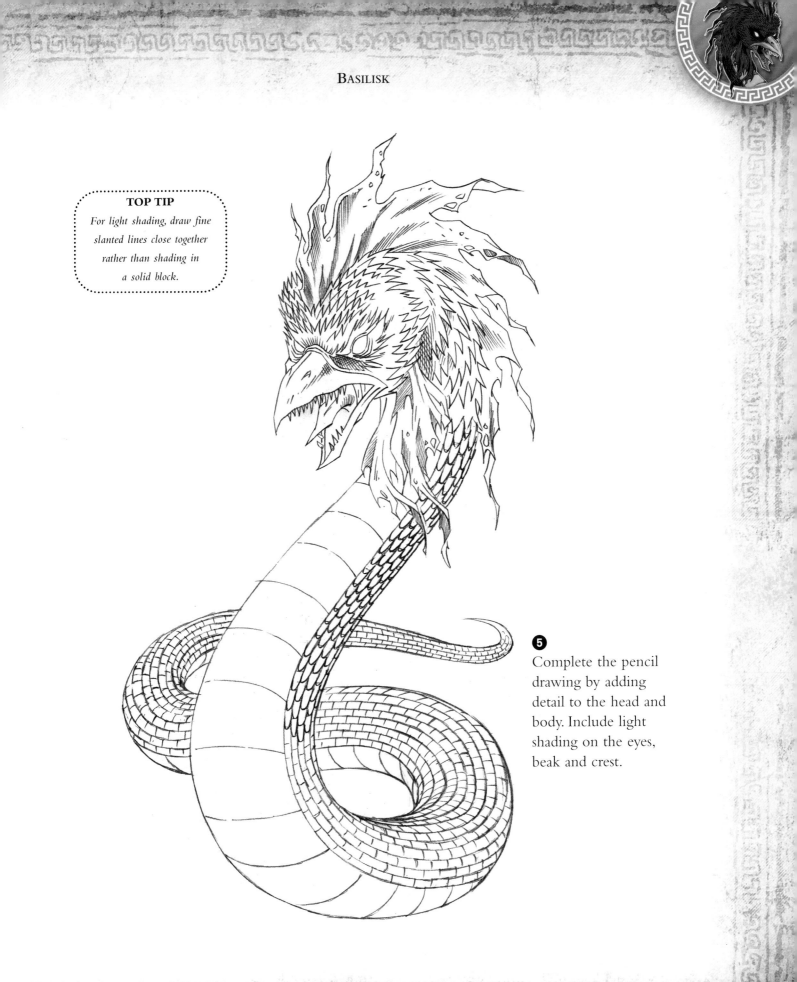

TOP TIP

For light shading, draw fine slanted lines close together rather than shading in a solid block.

5

Complete the pencil drawing by adding detail to the head and body. Include light shading on the eyes, beak and crest.

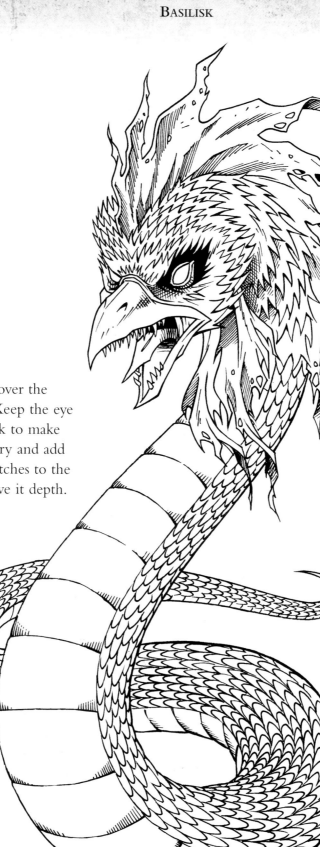

6

Now ink over the drawing. Keep the eye socket dark to make it look scary and add heavier patches to the crest to give it depth.

7

The final stage is to colour your work.

Use a light grey base for the beak followed by buttercup yellow and rusty orange.

Colour the underbelly with a beige base layer. Then add light grey.

Build up the colours on the crest with layers of orange and red. Use mid-grey to create darker areas.

The scales have a warm red base followed by a darker red and dark grey for shading.

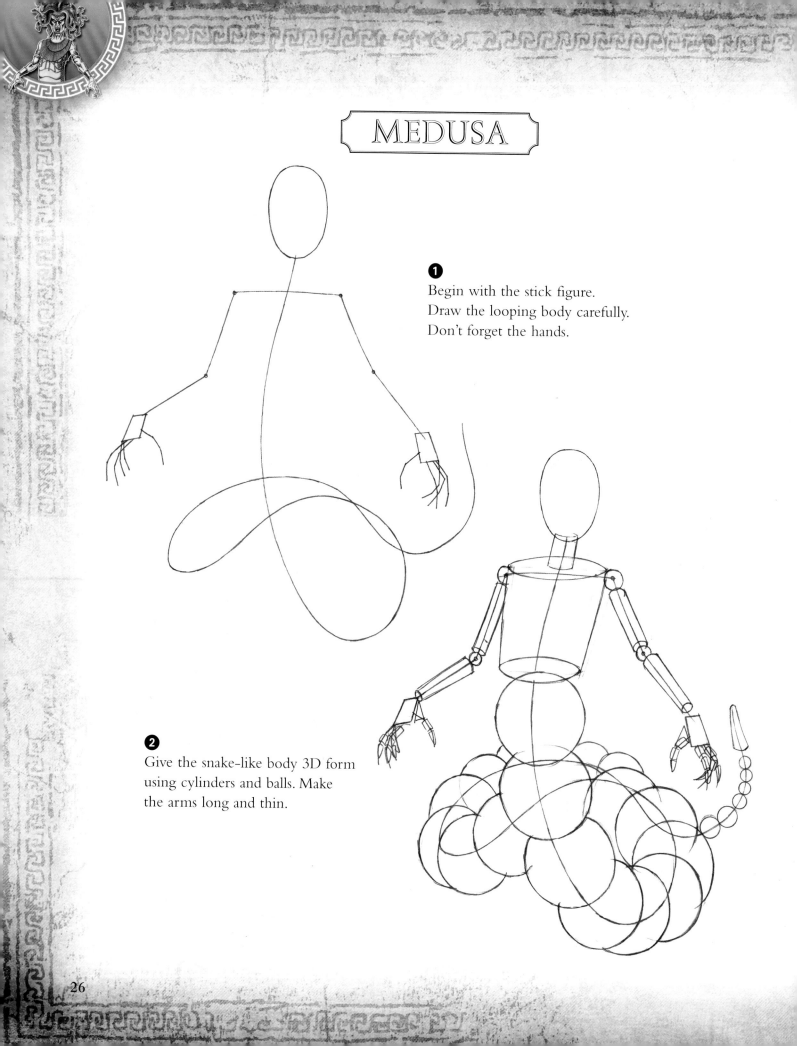

MEDUSA

1

Begin with the stick figure.
Draw the looping body carefully.
Don't forget the hands.

2

Give the snake-like body 3D form
using cylinders and balls. Make
the arms long and thin.

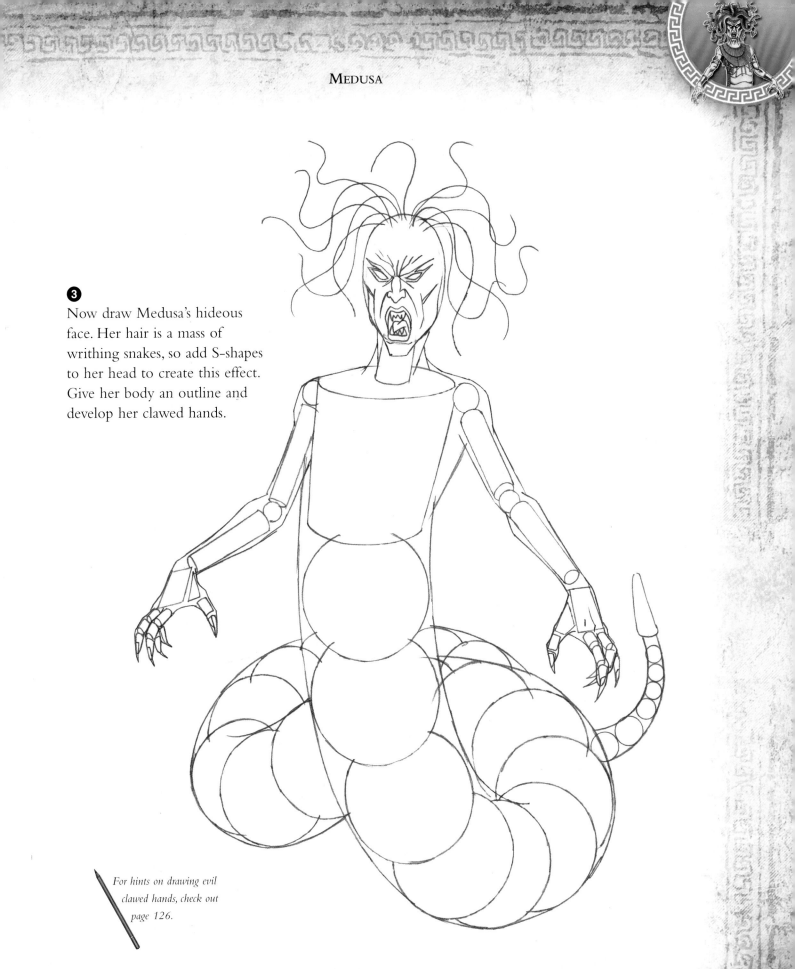

3

Now draw Medusa's hideous face. Her hair is a mass of writhing snakes, so add S-shapes to her head to create this effect. Give her body an outline and develop her clawed hands.

For hints on drawing evil clawed hands, check out page 126.

4 Remove the construction shapes, then draw the scales on the body. Add the necklace, bangles and headdress. Improve Medusa's hair by giving the snakes an outline and drawing their heads.

Find out how to draw snakes' heads close up on page 32.

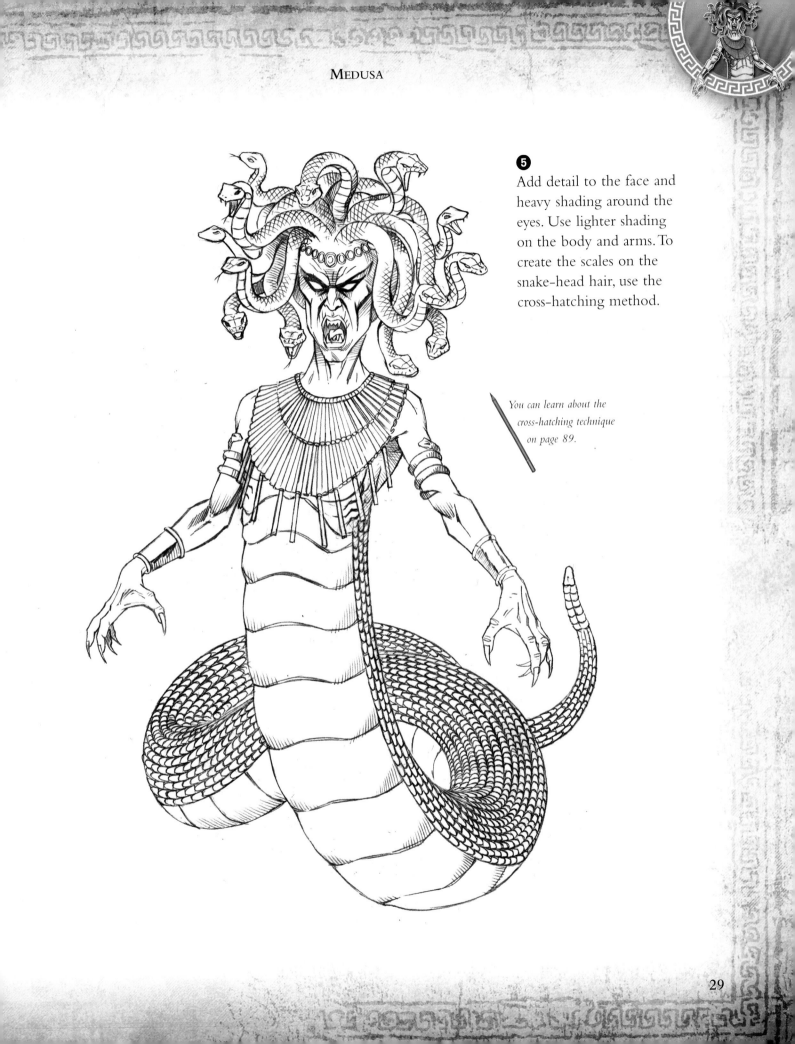

5 Add detail to the face and heavy shading around the eyes. Use lighter shading on the body and arms. To create the scales on the snake-head hair, use the cross-hatching method.

You can learn about the cross-hatching technique on page 89.

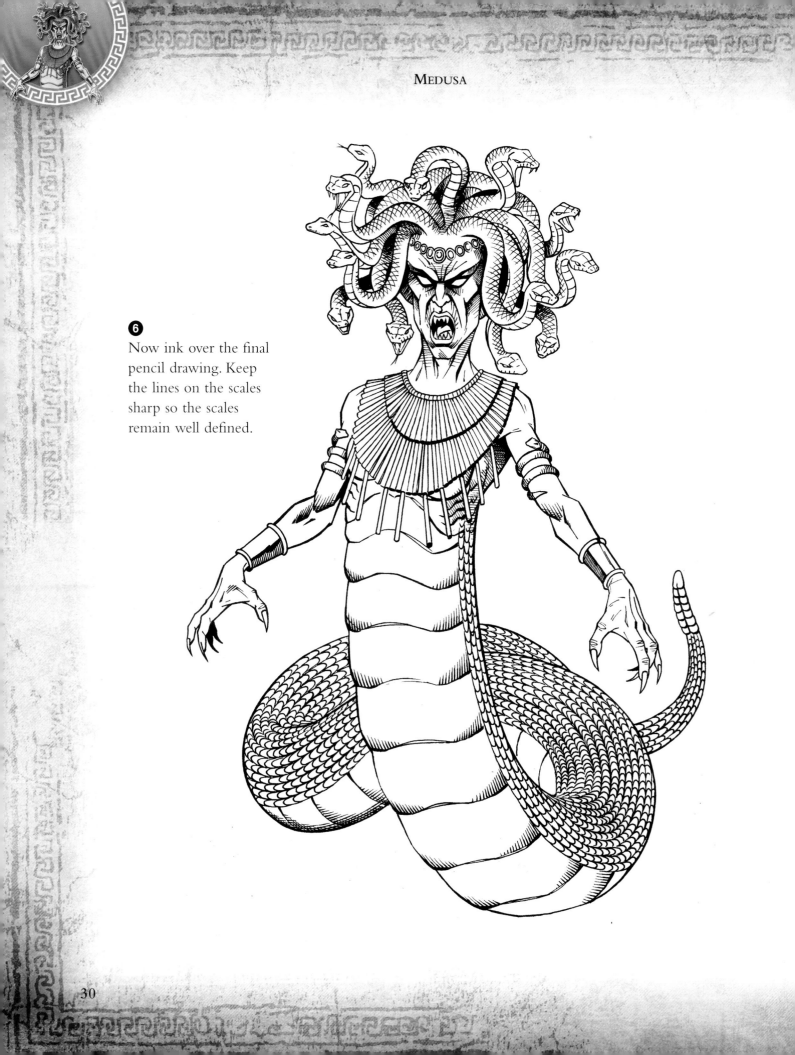

6

Now ink over the final pencil drawing. Keep the lines on the scales sharp so the scales remain well defined.

 7

You can bring out
Medusa's fierceness and
snake-like qualities when
you colour your art.

A pale skin tone
has been used for
the head and
arms followed
by layers of pale
green and grey.

Colour the gold jewellery
with a yellow base. Add
yellow ochre and orange
to create darker tones.

The main body
has a pale olive
base of yellow
and grey.

The scales are grass green and emerald
green followed by dark green. You can
make green darker by adding dark grey.

31

Scales and Snakes

Drawing Scales

It's difficult to draw scales on a curved body. Here is a way that will make it easy for you to complete a detailed drawing. It's called the brick method.

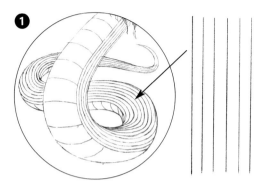

❶ Start by drawing a series of vertical lines.

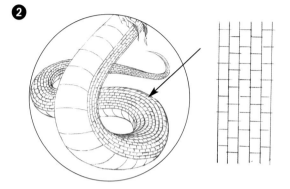

❷ Next add staggered horizontal lines between the vertical lines, as if you were drawing a brick wall.

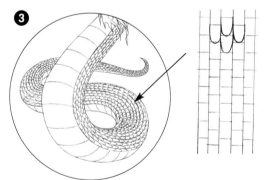

❸ Round off the brick shapes to create the scales. Keep on doing this until you have a complete snake's skin.

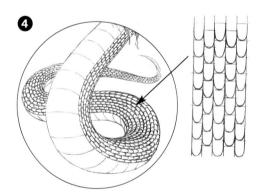

❹ The final result is incredibly realistic. Take a look at the Basilisk on page 24 for the full impressive effect.

Snake Heads

When you come to draw the Medusa on pages 26–31, you will see that the snakes on her head are quite small. Here is a larger snake for you to study and copy.

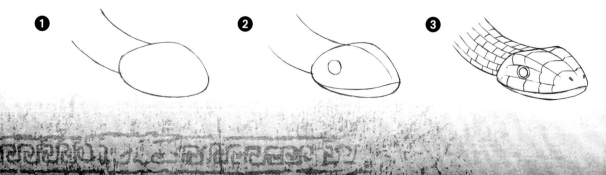

Wing Structure

Dragon Wings

A dragon's wings are similar to those of a bat. So it makes sense to base the construction of a dragon's wings on this small night-flying animal.

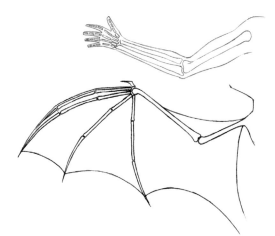

The structure of a bat's wing is similar to that of a human arm and hand. The bones of the wing form the shape of an arm and bend in the same places. The end of the wing is like a human hand with four fingers and a short thumb. The difference is that a bat has a thin membrane stretching over this structure.
On this basis, you can break down drawing a bat's wing into the simple steps below.

Picture 1 First plot out the wing. You need a short 'thumb' at the top and four longer 'fingers'.

Picture 2 Turn these into proper shapes by adding a second line close to the first line for each finger. Sktech the outline of the membrane.

Picture 3 Now you have the wing structure, highlight the bones by going over them with a thicker line.

Picture 4 Clean up the drawing and add detail to the membrane to bring out the skin's texture.

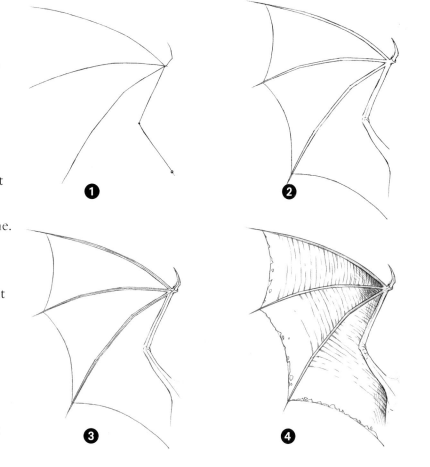

DEMI-HUMANS

Half-human creatures stalk history and are famed for their encounters with mortals. The **Centaur** was part-human, part-horse. This race of savage fighters are believed to have taught hunting techniques to humans. In Greek mythology, the **Sphinx** attempted to impart her wisdom to mortals through riddles until she was defeated by Oedipus. He solved her riddle and was made king for destroying the monster. The most savage demi-human was the **Minotaur**, the half-man, half-bull monster so fearsome that the king of Crete locked him inside a labyrinth until he was slain by Theseus with the sword of Aegeus.

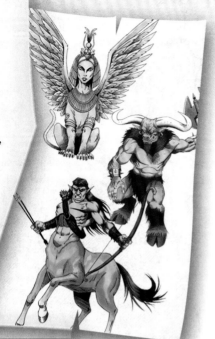

CENTAUR

1

Begin with the stick figure. Remember the top half is human and the bottom half is a horse. Make sure you include the hooves.

Study pages 68-69 to help you draw the horse-like part of the Centaur's body.

2

Next add the construction shapes. You are mainly using cylinders in this drawing. Keep the cylinders wide on the rear legs at the top.

3

Sketch the angry face and pointed ears. Then add the skin by drawing around the construction shapes. The tail should flick outwards.

4
Erase the construction shapes, then draw the Centaur's bow and arrows. Notice how the bow has a snake's head at the tip. Keep the lines of the arrows straight. Add the flowing hair, body armour and horse's tail.

5
Shade your drawing. Pay particular attention to the underside of the Centaur's hair, chest and tail. Leave areas of the hair white to create highlights. Add fine detail to the face.

6

Ink over the pencil lines. Tackle the small details on the Centaur's armour carefully so the patterns remain well defined.

You'll discover lots of tips on page 50 to help you draw a striking face for the Centaur.

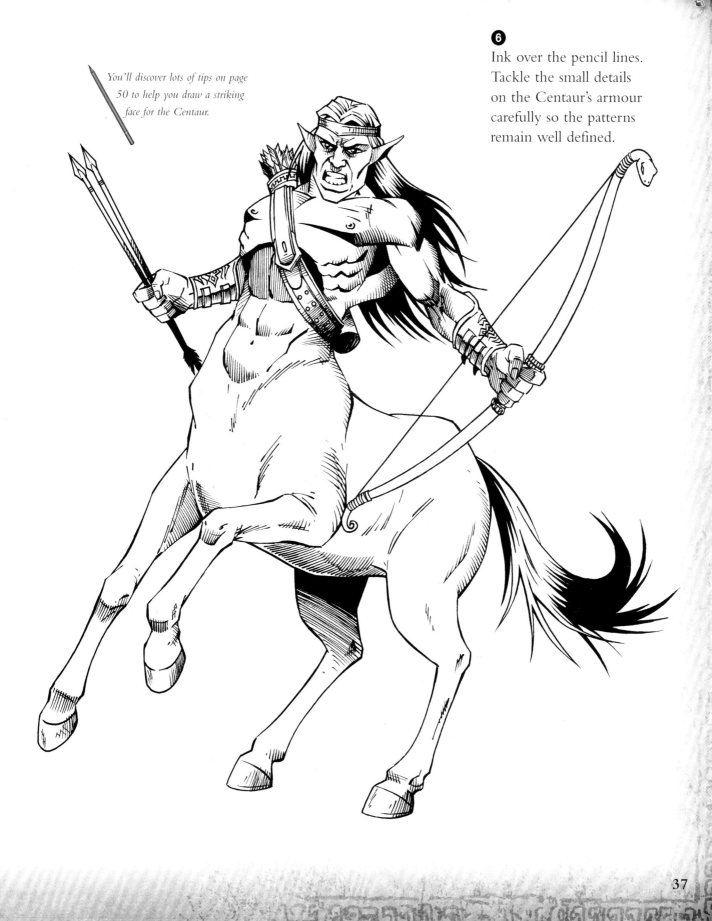

7

Go over your drawing in colour. We've used a cool palette to create a moody feel.

A mixture of blue and grey for the hair adds an other-worldly quality.

Start with a pale skin tone for the upper body. On top, use a warmer skin tone to bring out the muscles.

For the lower body, try a base layer of cool grey followed by darker grey. Include hints of pale blue.

SPHINX

1

Start with the stick figure.
Notice the Sphinx is in a
sitting position. Make sure
the wings stretch high
above the head.

2

Next create the body shape.
Use long thin cylinders for
the limbs and wing structure,
and small balls for the joints.

3

Add the face. Then give the Sphinx her skin by drawing around the construction shapes. Include a tail and cat-like paws and claws.

Check out page 51 for instructions on how to create the face of the Sphinx.

4

Rub out the construction shapes. Then add the ornate headdress, necklace and snake bangles. Build the wings by layering the feathers.

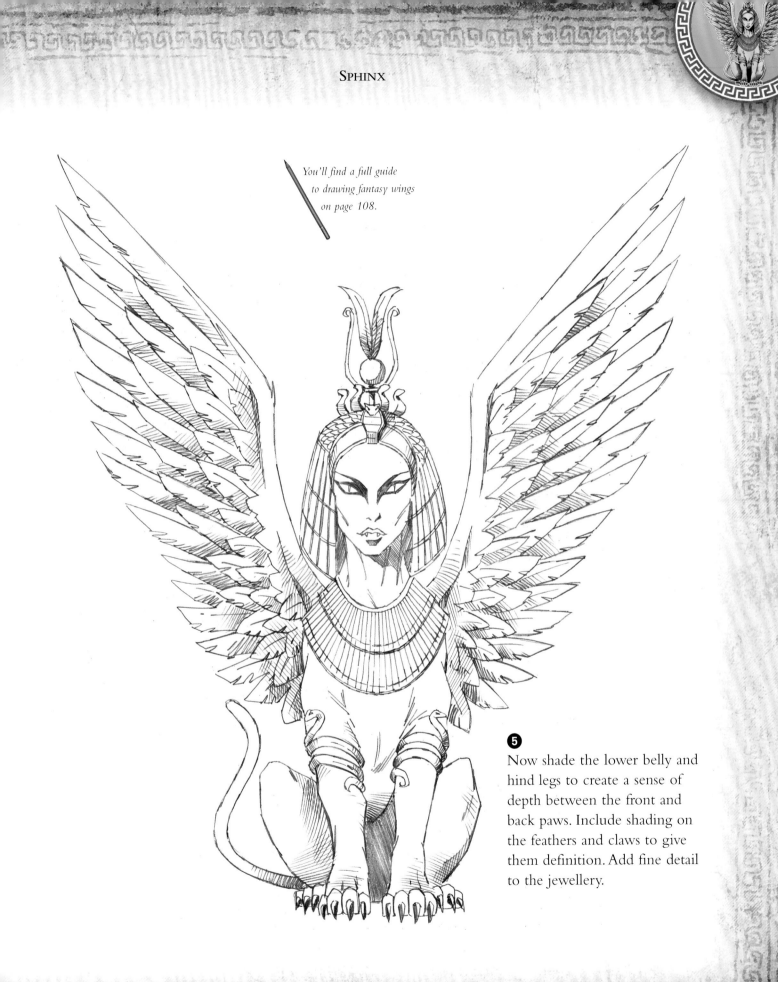

*You'll find a full guide
to drawing fantasy wings
on page 108.*

5

Now shade the lower belly and
hind legs to create a sense of
depth between the front and
back paws. Include shading on
the feathers and claws to give
them definition. Add fine detail
to the jewellery.

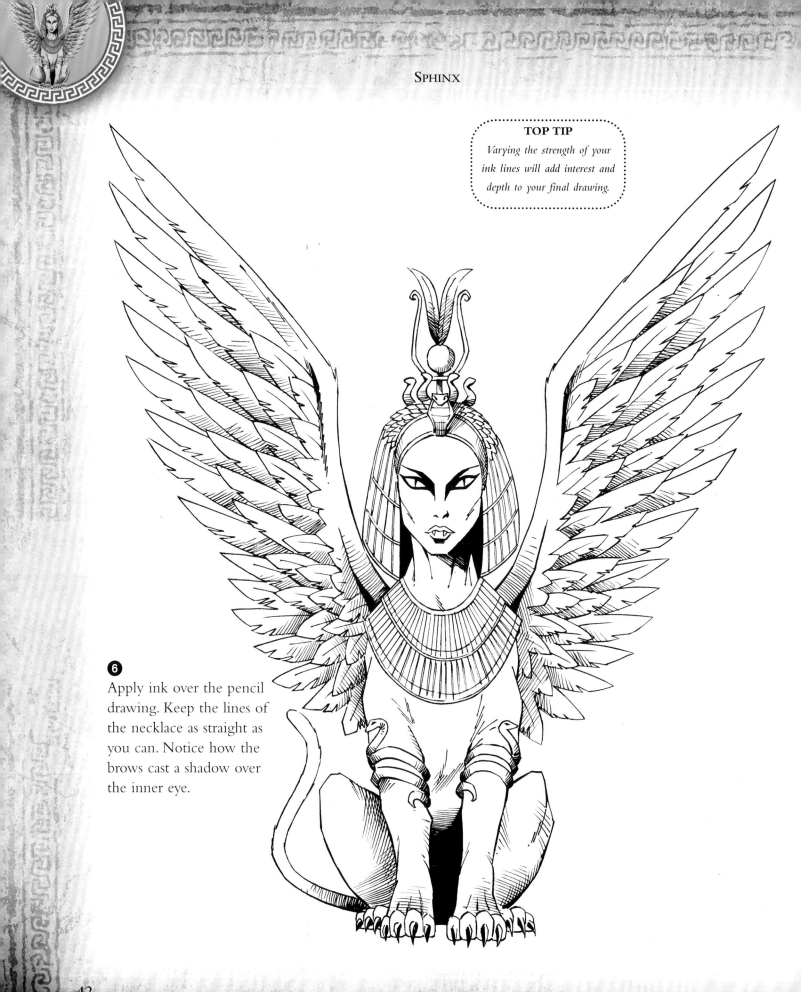

6

Apply ink over the pencil drawing. Keep the lines of the necklace as straight as you can. Notice how the brows cast a shadow over the inner eye.

❼ Bring your art to life by adding colour. Start with a beige base over the whole area.

Use a pale skin tone for the ghostly face and rich yellow for the spooky cat's eyes. A turquoise mouth will make the Sphinx look even icier.

Build up interest by applying layers of colour. Use shades of sand, yellow and brown.

Colour the gold jewellery with sandy and yellowy brown. For the gemstones, use a jade-green colour to create contrast.

MINOTAUR

 1

Start with the stick figure. You need curved lines for the horns and ovals for the clumpy feet. Don't draw the fingers on the Minotaur's left hand. It's easier to add these later, gripping the axe.

2

Build the body using chunky cuboids and wide cylinders. Form the axe with a large oval and a straight, angled line for the handle.

Go to page 51 for more tips on how to draw a Minotaur's stocky bull-like body.

TOP TIP

Although the Minotaur has a bull's head, you can give his face more character by mixing in human features. This is a useful technique for many fantasy creatures.

3

Draw the face and goat-like beard. Then add the skin outline. Shape the feet into cloven hooves using upside-down V-shapes. Improve the axe.

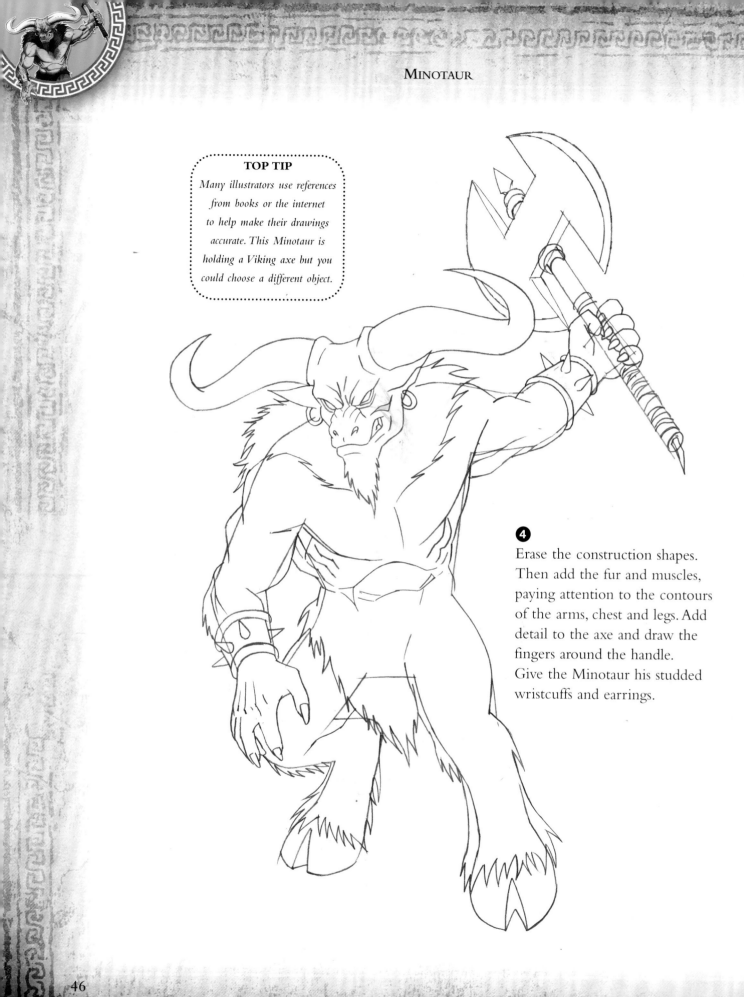

TOP TIP

Many illustrators use references from books or the internet to help make their drawings accurate. This Minotaur is holding a Viking axe but you could choose a different object.

4

Erase the construction shapes. Then add the fur and muscles, paying attention to the contours of the arms, chest and legs. Add detail to the axe and draw the fingers around the handle. Give the Minotaur his studded wristcuffs and earrings.

5

Finish the pencil drawing with fine detail to the body. Shade the areas you will be inking heavily in the next step.

6

Now ink your artwork.
Use solid areas of ink to add
drama and emphasise the
Minotaur's bulk.

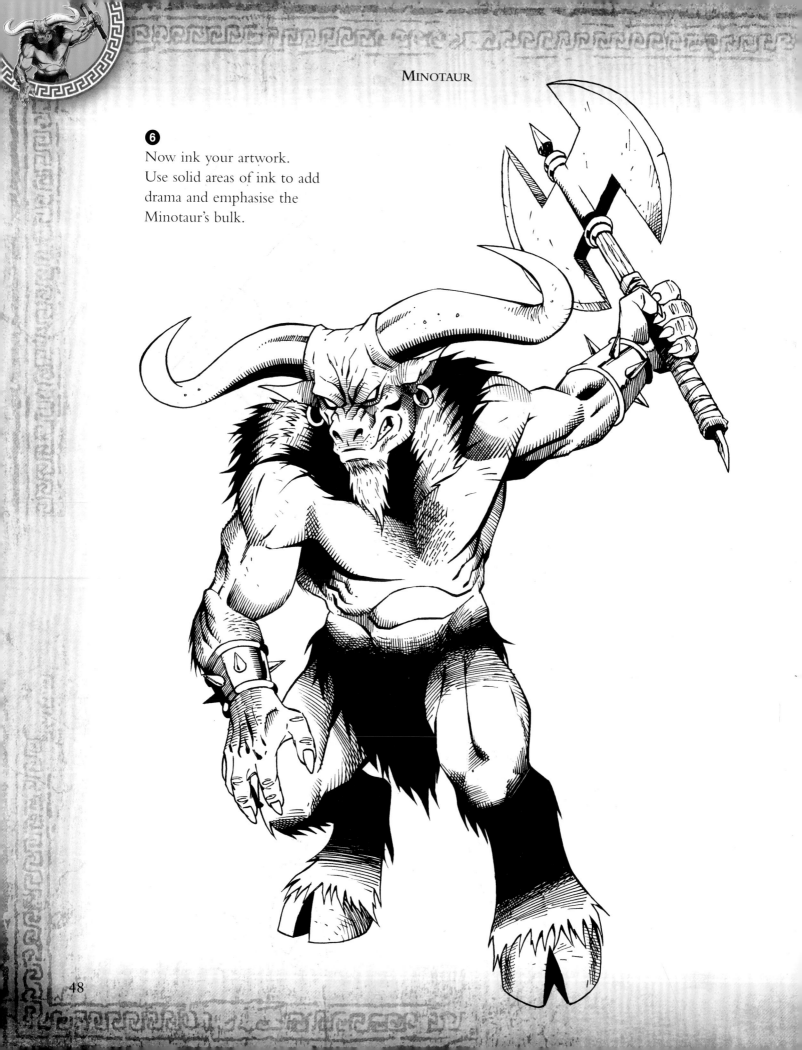

7

Start your colour work with a base layer of beige. Include hints of green and grey.

The axe is coloured blue-grey. A darker grey is used for the shading.

Brick beige was used to colour the horns.

Build up the skin with cool tones. We've used layers of green-brown and grey.

Warm tones work well for the rich furry mane. Try brown mixed with red.

Demi-human Faces and Bodies

The Horse-like Centaur

All of the creatures in this section are a mix (hybrid) of human and animal features. Although the head of the Centaur has a human appearance, it still has characteristics that separate it from being purely human. This exercise will show you how to change the shape and appearance of the human face to create a demi-human.

Picture 1 Start with an oval. Then draw lines to roughly work out where the eyes, nose and mouth will sit.

Picture 2 Next add the face. The eyes are set at a slight angle to indicate a point of difference from a human.

Picture 3 Draw the pointed ears. Instead of human ears, the Centaur has ears more like those of a horse.

Picture 4 Next work on the hair. Note how it flows like a wild horse's mane. Remove the construction lines.

Picture 5 Finally shade in the hair leaving sections of white for highlights. Also add shading to the face, particularly around the eyes.

The Centaur is now a hybrid of a horse and a human but with his own unique identity.

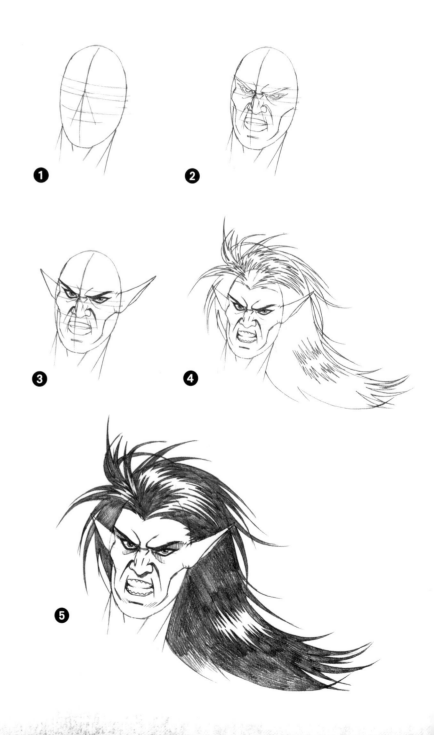

The Feline Sphinx

The Sphinx is a feminine hybrid of a lionness and a human, with the wings of an eagle. Check out the tips below to help you draw her cat-like face and decorative headdress.

Picture 1 Start with an oval shape for the head, then map out the eyes, nose and mouth.

Picture 2 Next add detail to the face. The eyes are turned inwards and set at an angle. A real cat has round eyes but this is a fantasy character so we can use the approach shown here to create a cat-like effect.

Picture 3 The four ornaments around the top of the headdress are snakes. Notice how they are all S-shaped. The snake at the front is a cobra.

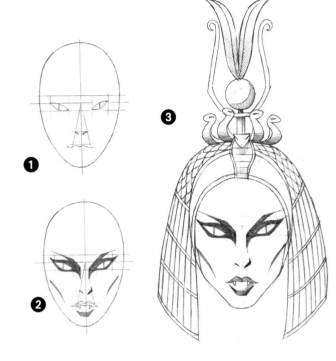

The Bull-like Minotaur

The Minotaur is half human and half bull. Below we show you how to draw his stocky frame.

Picture 1 shows the hind legs of a bull. In **Picture 2** you can see that the construction of the bull's leg is similar to that of the hind leg of a horse. This basic leg shape will form the lower half of the Minotaur. **In Picture 3** we have simplified the legs so they have a semi-human appearance. We have drawn the knees heavily bent and made them muscular.

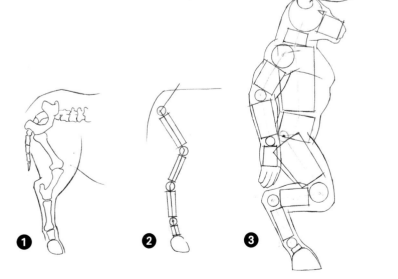

UNEARTHLY BEASTS

Those monsters of folklore that were neither mortal nor demi-human we simply call 'the beasts'. The fearsome three-headed dog **Cerberus** was not just a monster, but guard of the underworld. No dead person could return to the land of the living under his powerful gaze. The magical and untameable **Unicorn** had a horn that acted as an antidote to any poison. Finally, there was **Chimera** – the lion, goat and serpent hybrid that devastated human populations until its death at the hands of Bellerophon, a hero and slayer of monsters who rode on Pegasus.

CERBERUS

1

Draw the stick figure. Cerberus has three heads, so include three circles. He has four legs and paws like a dog. Don't forget a curved line for the tail.

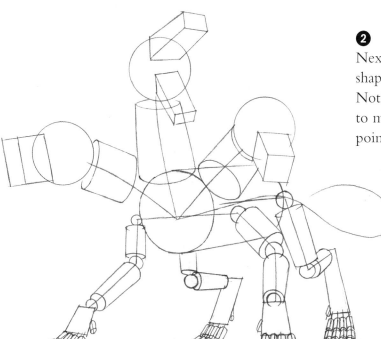

2

Next draw the construction shapes, using cylinders and cuboids. Notice how we have added shapes to make each of the creature's heads point a different way.

3

Now draw the three heads. Focus on the open jaws and sharp snarling teeth as well as the eyes and nose. Add the skin outline and develop the paws and claws.

4

Erase your construction shapes. Then give Cerebus the chains around his necks. Add lines to emphasise the contours of his body.

5

Now clean up the drawing. Add shading and more detail to the body and chains. Draw saliva dripping out of the beast's jaws to make him look ferocious.

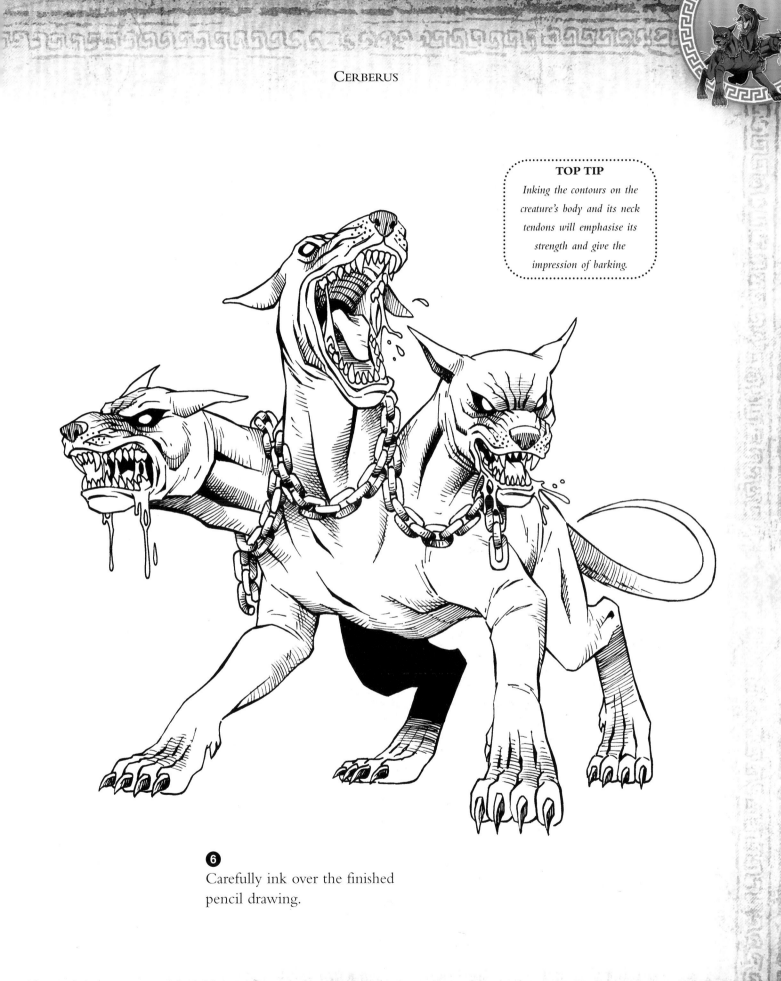

TOP TIP

Inking the contours on the creature's body and its neck tendons will emphasise its strength and give the impression of barking.

❻

Carefully ink over the finished pencil drawing.

7

Add colour to your drawing to make the animal look even more angry and frightening.

Use a medium grey for the base followed by layers of darker, warmer greys.

Apply cool grey for the chains. Create a rust effect by using sand-yellow and orange with a hint of green.

UNICORN

1

Start with the horse-like stick figure. Draw an angled line curved at the end for the back and tail, and four stick legs with hooves. You also need a curved line for the neck.

2

Add the construction shapes, using one large wide cylinder for the body and long, thin cylinders for the legs. Notice how the neck is a series of balls.

Take a look at pages 68–69 for more tips on how to draw horses.

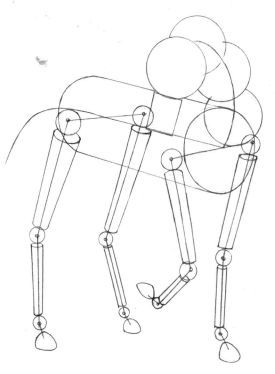

3
Next shape the Unicorn's head and add detail to the face. Draw the pointed horn, making sure the outer lines are straight. Add the skin.

4
Erase your construction shapes, then add the wild mane and tail. Draw contour lines to show the strength of the neck.

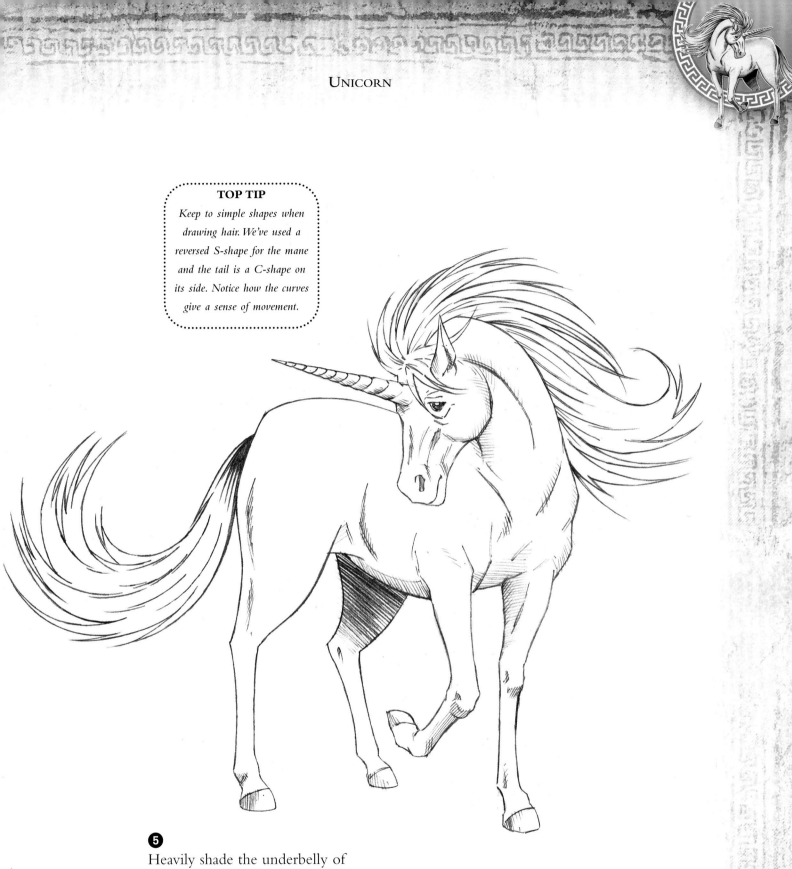

TOP TIP

Keep to simple shapes when drawing hair. We've used a reversed S-shape for the mane and the tail is a C-shape on its side. Notice how the curves give a sense of movement.

5

Heavily shade the underbelly of the Unicorn and the top of its tail. Lightly shade the contour lines to bring out the muscles. Fill in the eye and nostril.

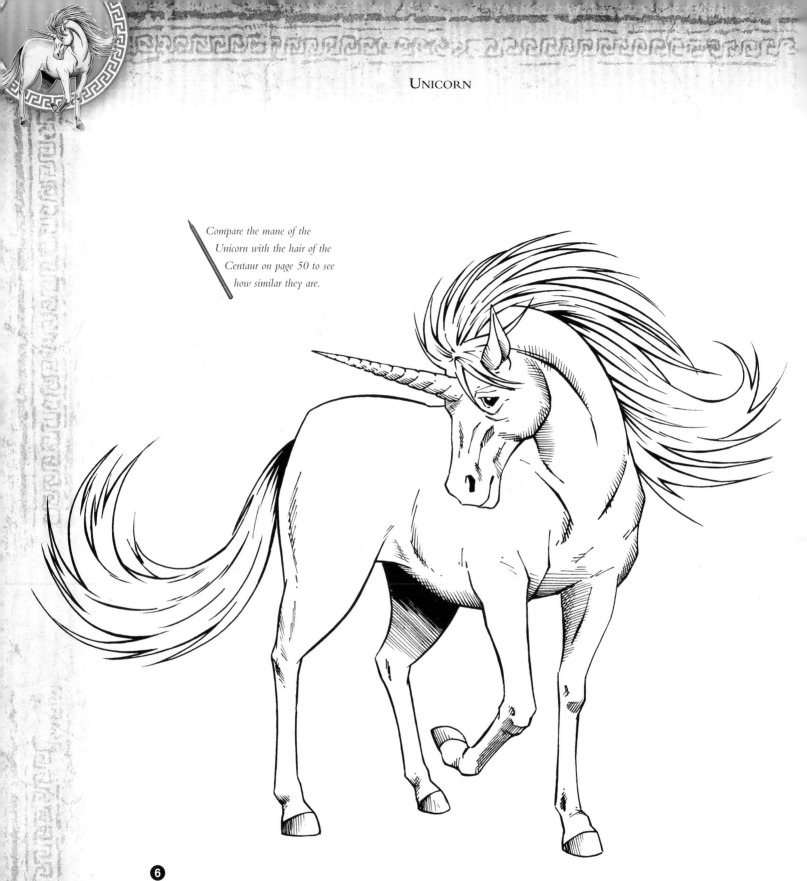

*Compare the mane of the
Unicorn with the hair of the
Centaur on page 50 to see
how similar they are.*

6

Ink over the pencil drawing.
Work carefully on the eye
leaving white highlights.

7

This drawing has been coloured using a pale grey base followed by a layer of pale blue.

Create the dappled skin with a blender marker. This type of pen contains a colourless ink, which spreads the colours underneath when you pull it across the page.

TOP TIP

You can also create dappling with a paintbrush when using watercolours. Load the brush up with a small amount of water and gently dab the coloured areas you want to blend.

Apply pale violet to the underbelly, inner leg and top of the tail to create a darker tone. Then add dark blue and dark grey.

CHIMERA

1

Start with the skeleton stick figure. Include two circles and a triangle for the lion's, goat's and snake's heads that form part of this four-legged beast.

2

Next add the construction shapes. There are lots of different shapes here, so spend time on this stage and look closely at the drawing.

3

Now draw the heads and develop the faces. Notice how each one is fierce, with narrowed eyes. Outline the lion's mane and turn the back feet into cloven hooves. Draw around the construction shapes to add form to the picture.

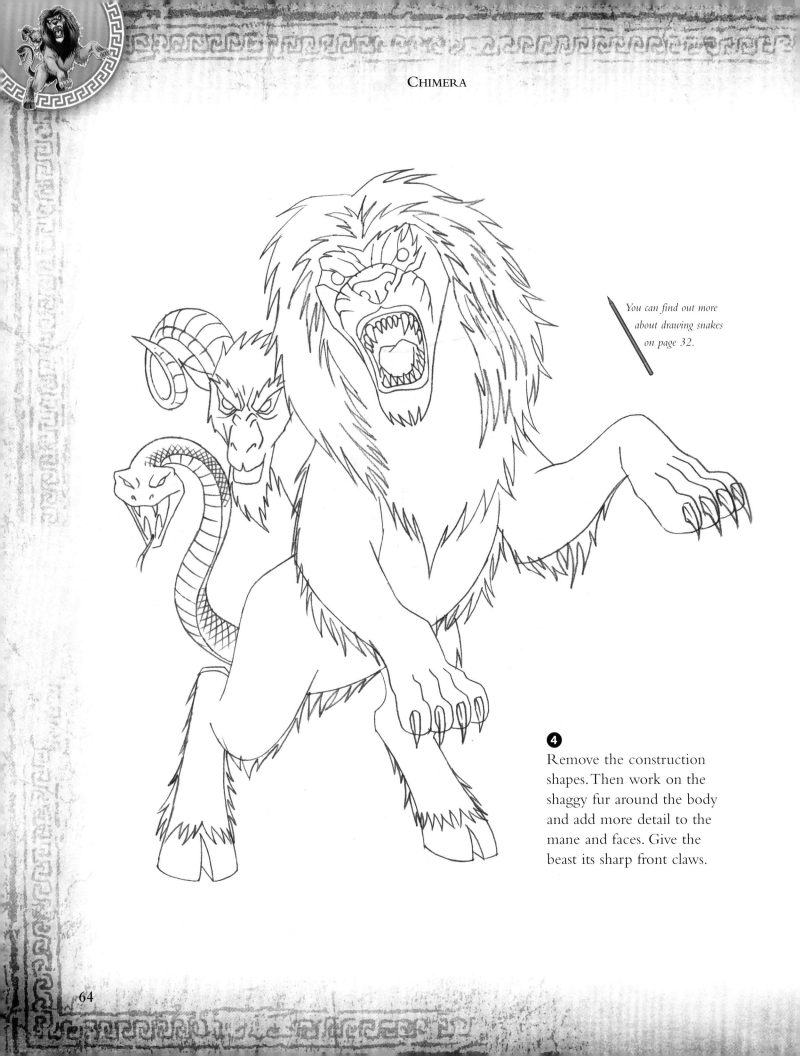

You can find out more about drawing snakes on page 32.

4

Remove the construction shapes. Then work on the shaggy fur around the body and add more detail to the mane and faces. Give the beast its sharp front claws.

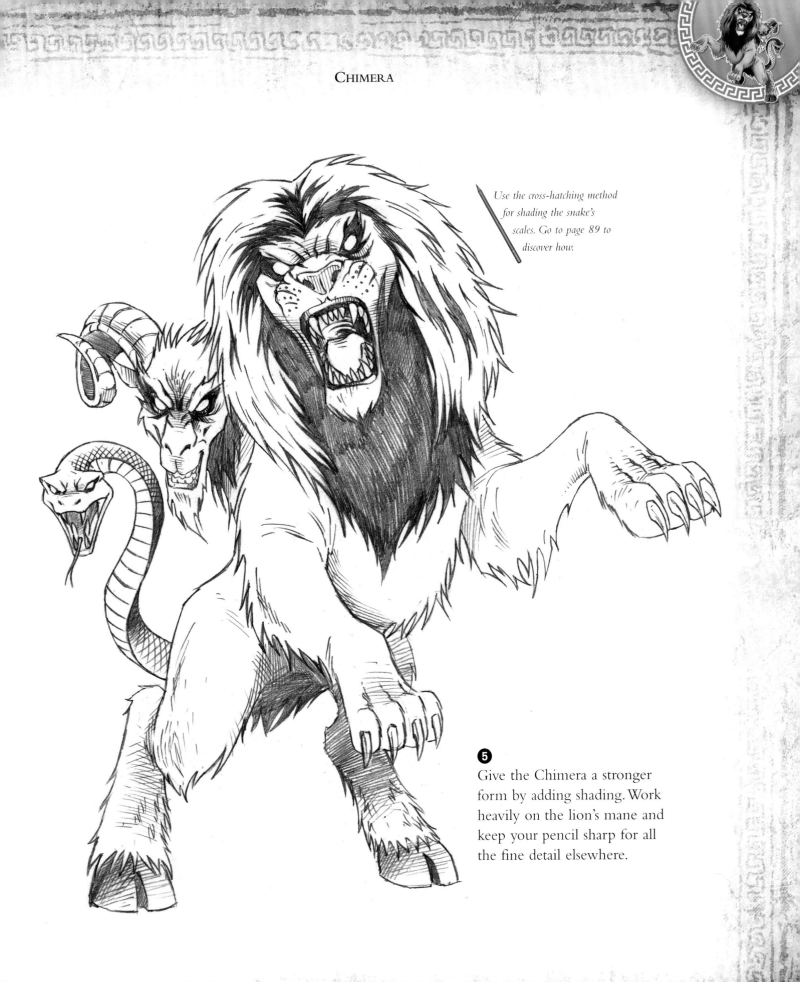

Use the cross-hatching method for shading the snake's scales. Go to page 89 to discover how.

5

Give the Chimera a stronger form by adding shading. Work heavily on the lion's mane and keep your pencil sharp for all the fine detail elsewhere.

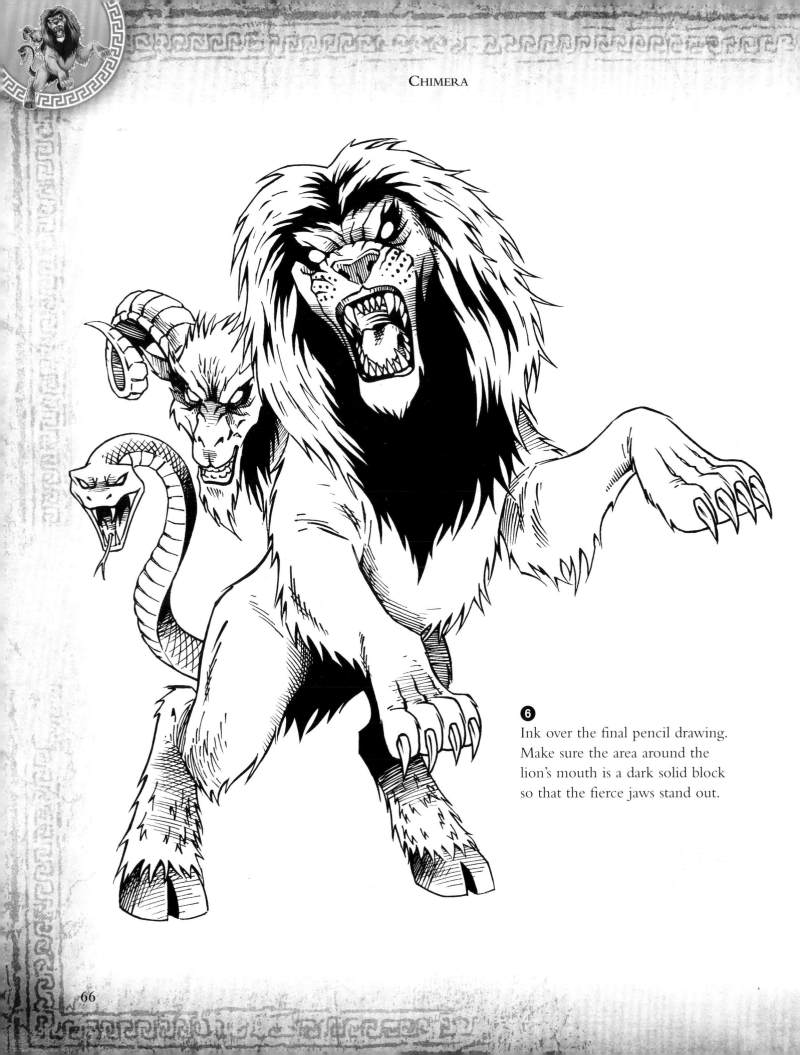

6

Ink over the final pencil drawing. Make sure the area around the lion's mouth is a dark solid block so that the fierce jaws stand out.

7

By colouring your work you can add even more drama.

Use a sand-coloured base for the goat's head. Then go over this with grey tones.

Use dusky red, orange and brown for the lion's mane and snake's scales.

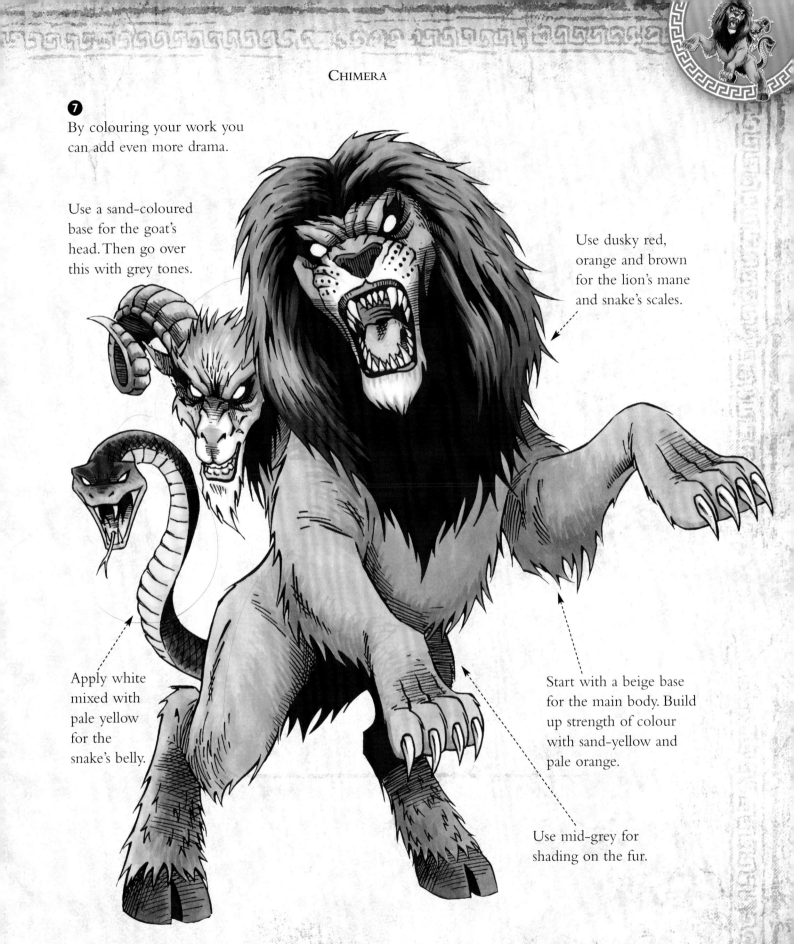

Apply white mixed with pale yellow for the snake's belly.

Start with a beige base for the main body. Build up strength of colour with sand-yellow and pale orange.

Use mid-grey for shading on the fur.

Drawing Horses

Contructing Horses

Horses are difficult creatures to draw because they have complex bodies. The following tips should be useful when drawing the Unicorn (pages 57–61) and Pegasus (pages 90–95).

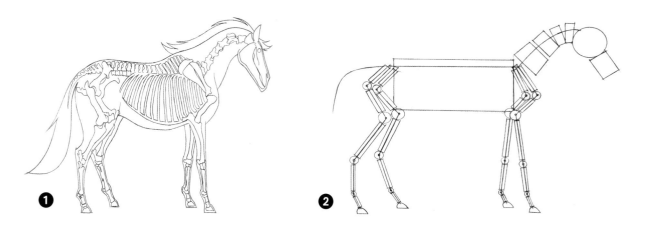

Picture 1 shows the detailed skeleton of a horse. Picture 2 shows you how to break down the construction of a horse accurately with all its joints. If you are a confident artist, then this is the best way to proceed.

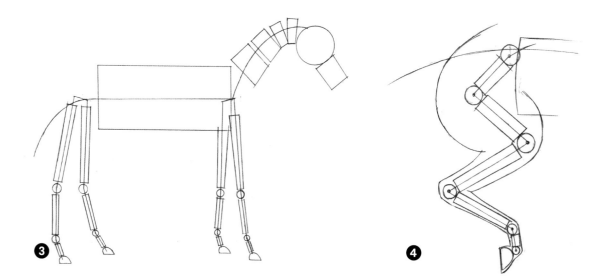

For those who would like a simpler starting block, take a look at Picture 3.

In Picture 4 you can see the building blocks needed to show a horse galloping.

Varying positions

Below are some examples showing you how to construct a horse in different positions.

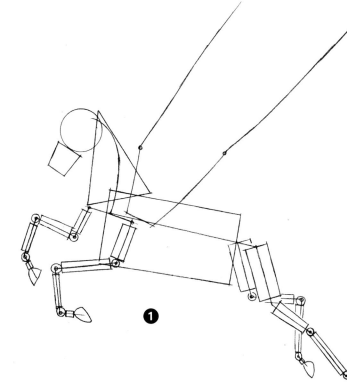

Picture 1 shows a horse leaping or flying through the air from the side. In **Picture 2**, the horse is looking towards the ground and facing us.

Note that a simple triangle shape has been used for the neck in Picture 1, while in Picture 2 the neck is made up of a series of circles. Try both methods to see which you prefer.

The more you practise drawing four-legged creatures, the easier it will become. In time, you will discover that you can draw the horse's outer shape without even thinking about all the technical detail. You just need to build up your skills slowly and develop your confidence. Once you have mastered the basics, you will be creating all kinds of amazing fantasy horses of your own!

SEA MONSTERS

The dark depths of the sea remain home to some of the world's most mystsical creatures. For centuries beasts such as the sea god **Triton**, with his fish's tail and razor-sharp trident, struck out at ships and reduced them to ocean debris. **Kraken**, the ocean's largest predator, would simply devour whole ships crushing them with its giant squid-like tentacles. The story of the elusive **Loch Ness Monster** continues in modern European legend. It has been frequently sighted but has always evaded capture.

TRITON

1

Start with the stick figure. Use a ruler to draw the long line for the spear-like trident. Add the three prongs at the top.

2

Next apply the construction shapes. Although Triton is half-man half-fish, give him human legs for now. Use triangles to create the fin on his tail.

TOP TIP

By giving Triton human legs at first, it will help you to blend the top and bottom half of his body together later on.

3

Draw Triton's face, crown and beard. Then go around the shapes to create an outline.

Go to page 88 for more detailed instructions on drawing Triton's face.

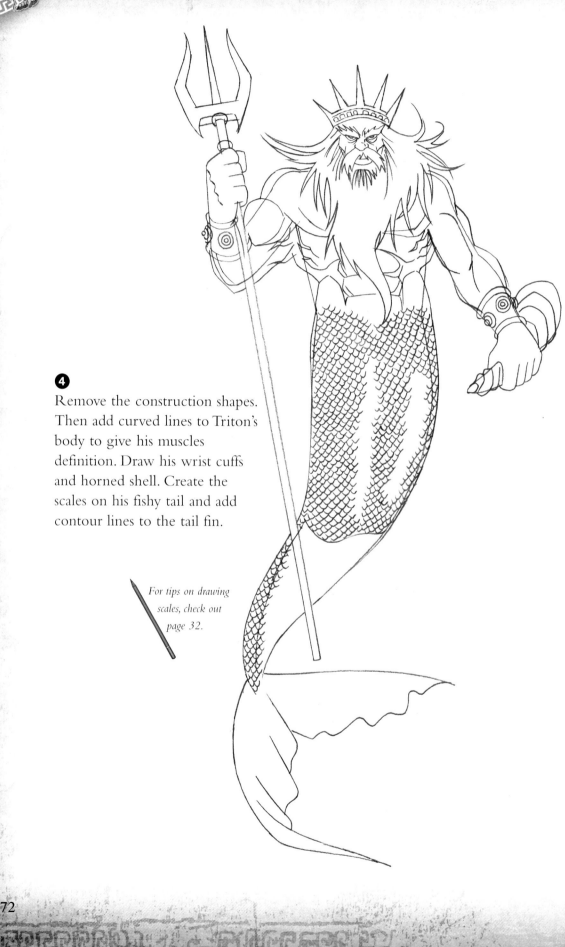

4

Remove the construction shapes. Then add curved lines to Triton's body to give his muscles definition. Draw his wrist cuffs and horned shell. Create the scales on his fishy tail and add contour lines to the tail fin.

For tips on drawing scales, check out page 32.

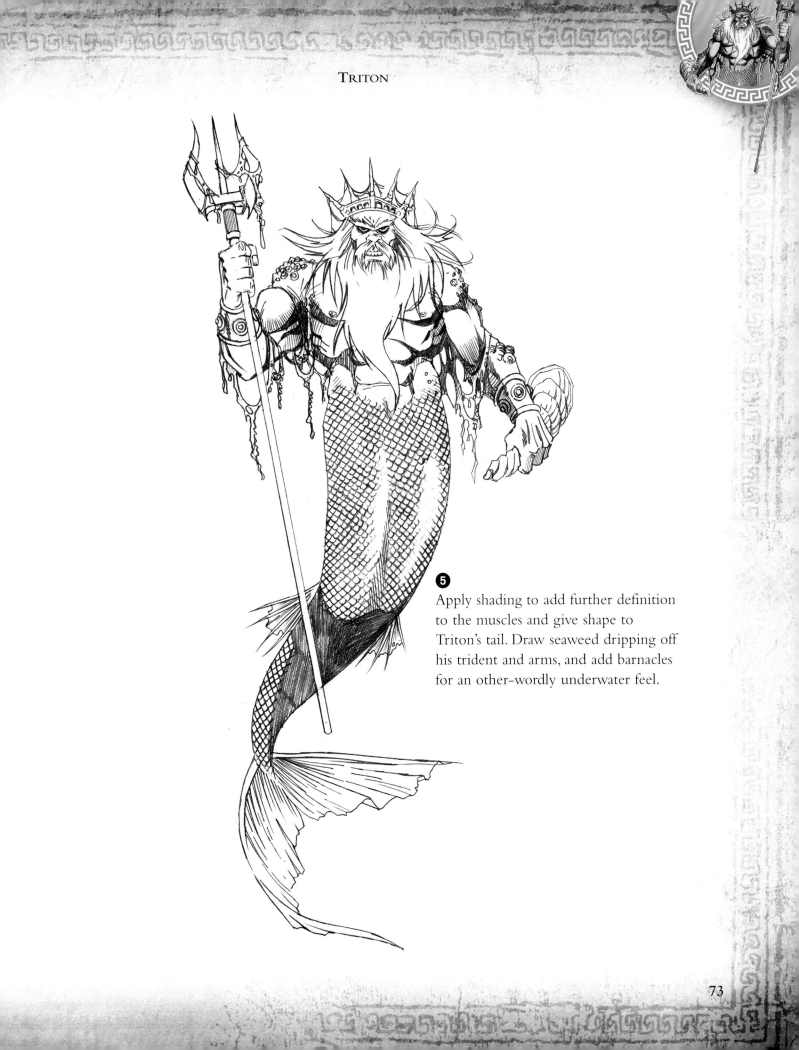

⑤ Apply shading to add further definition to the muscles and give shape to Triton's tail. Draw seaweed dripping off his trident and arms, and add barnacles for an other-wordly underwater feel.

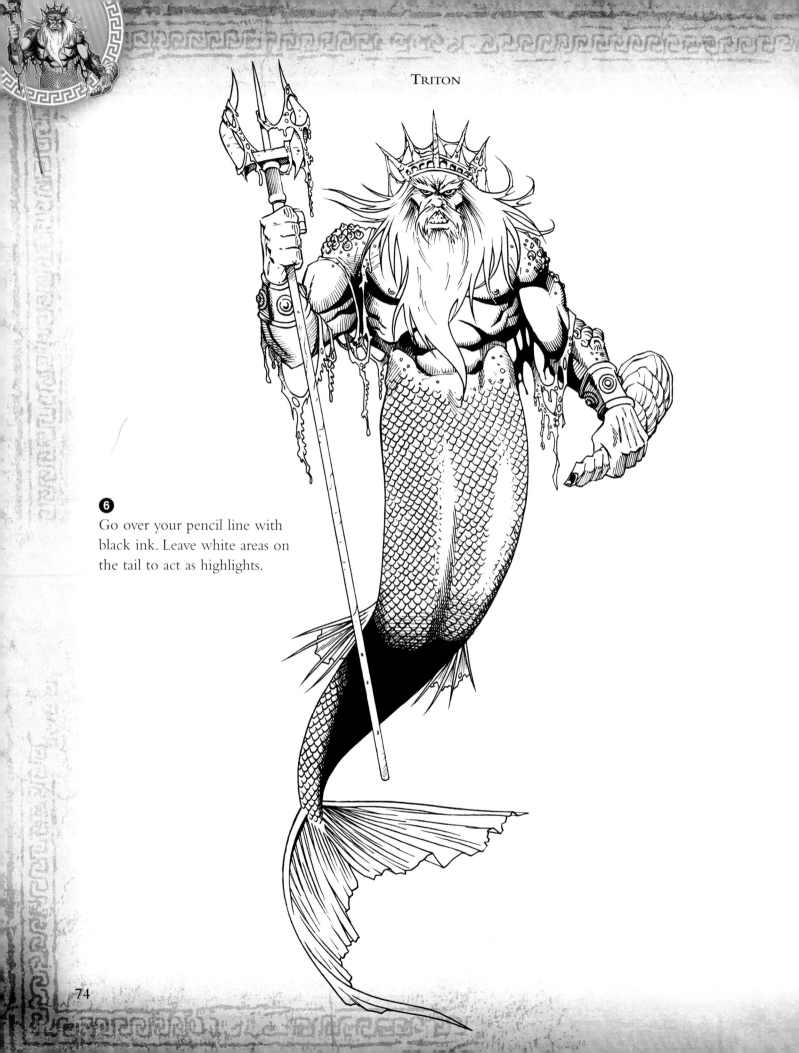

6

Go over your pencil line with black ink. Leave white areas on the tail to act as highlights.

TRITON

The beard is white with
hints of grey and green.

7

You can turn Triton into
a mighty shimmering
merman when you
colour your work.

Use a pale skin tone for
the upper body with
pale green and grey
at the muscle edges.

Colour the wristbands,
trident and crown with
yellow ochre and orange
to create darker tones.

Use a pale aqua base
for the tail followed by
darker greens. Emerald
and meridian work
well here.

KRAKEN

1

Draw the stick figure. You need a circle and a triangle for the head and body, and six curves for the squid-like tentacles.

2

Give form to the tentacles by adding circles down the length of each curved line. Include a cuboid to represent the ship the Kraken is destroying.

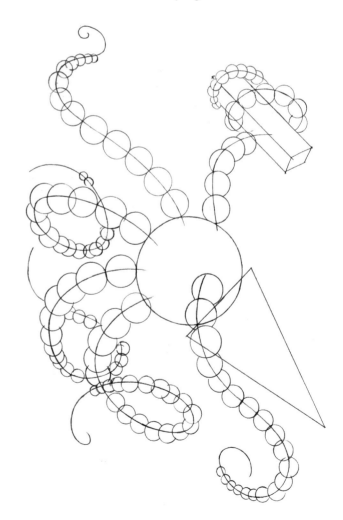

TOP TIP

By drawing the shape for the ship at this early stage, you will find it much easier to accurately construct the tentacle grabbing hold of it.

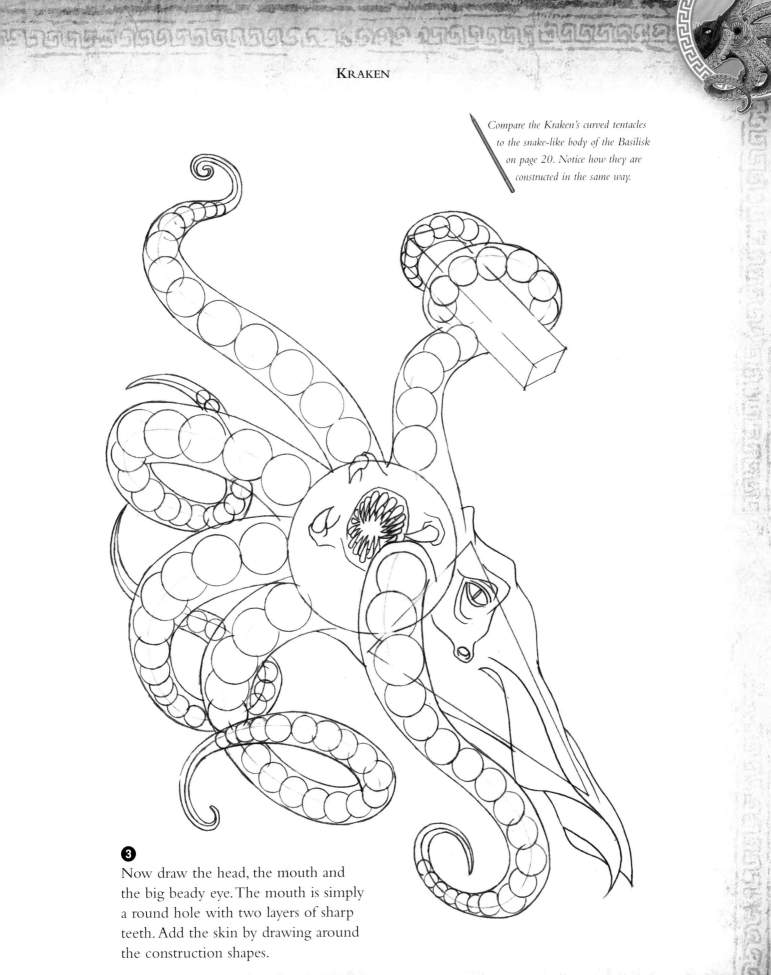

Compare the Kraken's curved tentacles to the snake-like body of the Basilisk on page 20. Notice how they are constructed in the same way.

❸

Now draw the head, the mouth and the big beady eye. The mouth is simply a round hole with two layers of sharp teeth. Add the skin by drawing around the construction shapes.

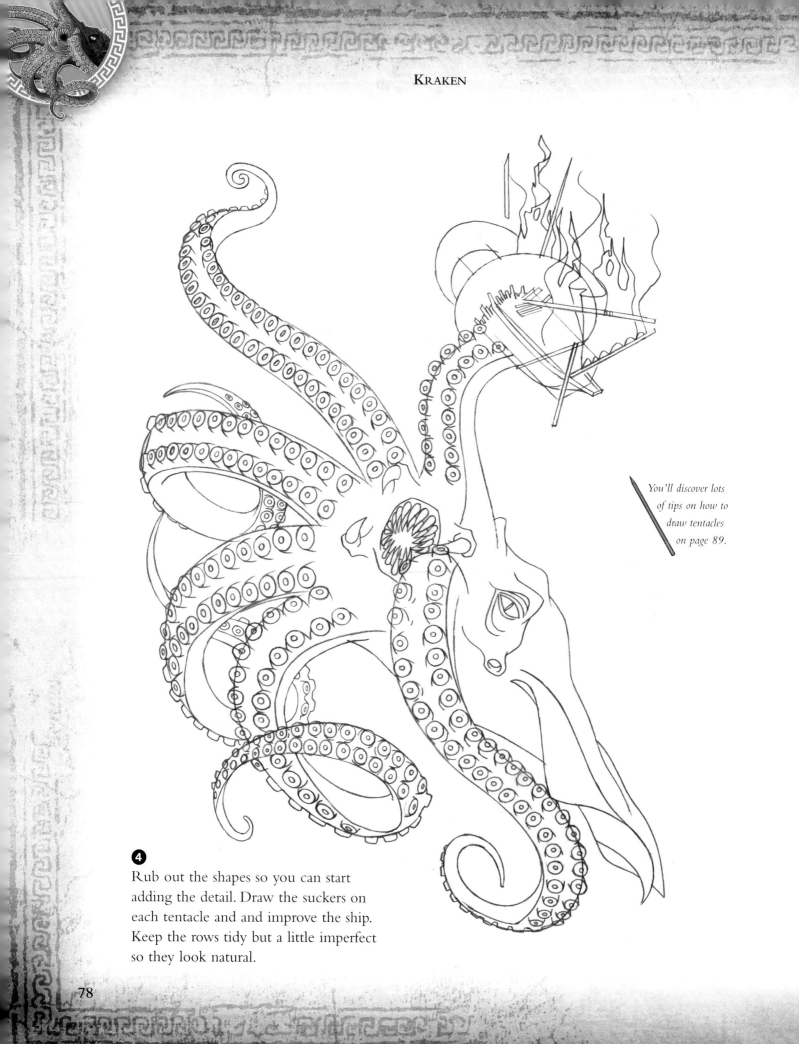

You'll discover lots of tips on how to draw tentacles on page 89.

4

Rub out the shapes so you can start adding the detail. Draw the suckers on each tentacle and and improve the ship. Keep the rows tidy but a little imperfect so they look natural.

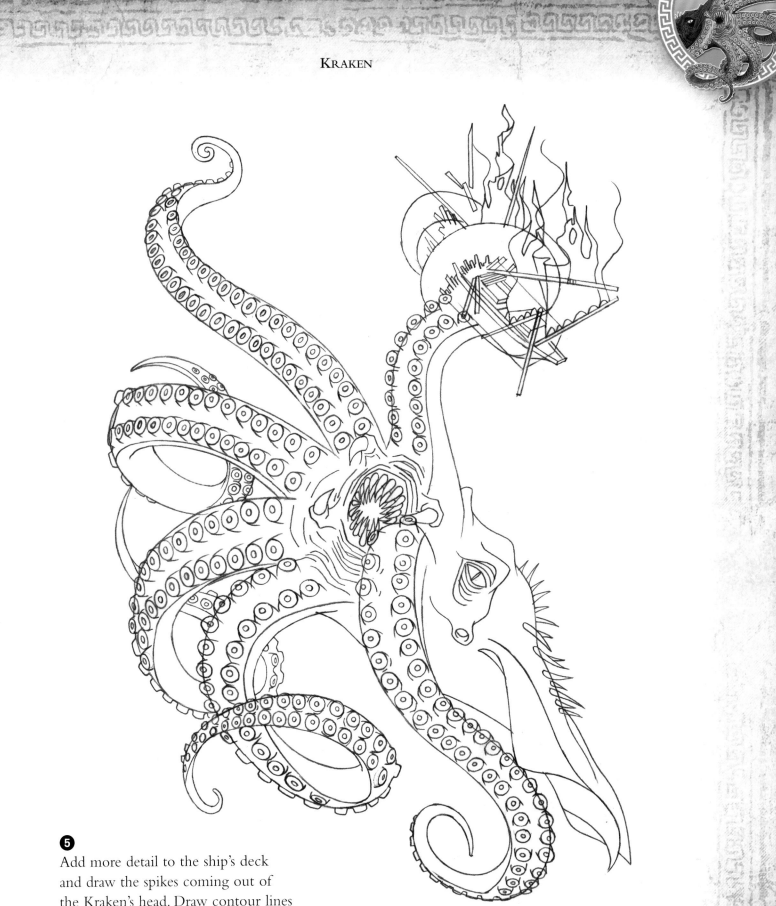

5

Add more detail to the ship's deck and draw the spikes coming out of the Kraken's head. Draw contour lines around the mouth to suggest how the Kraken sucks in its prey.

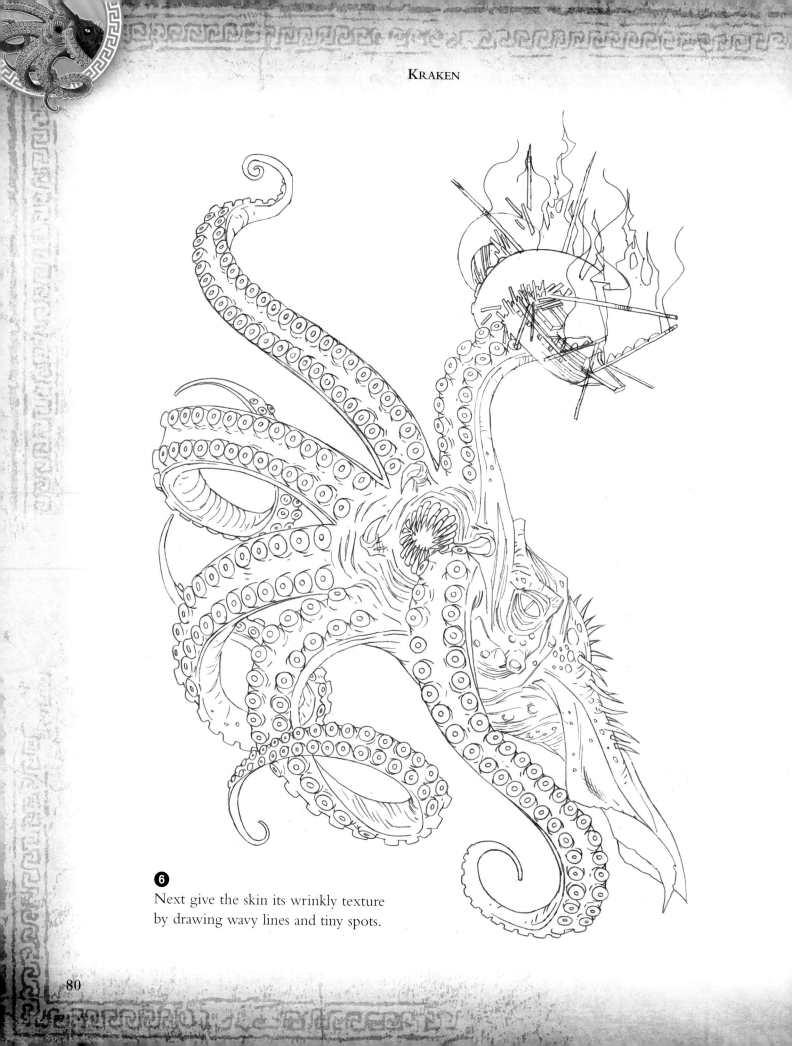

6

Next give the skin its wrinkly texture
by drawing wavy lines and tiny spots.

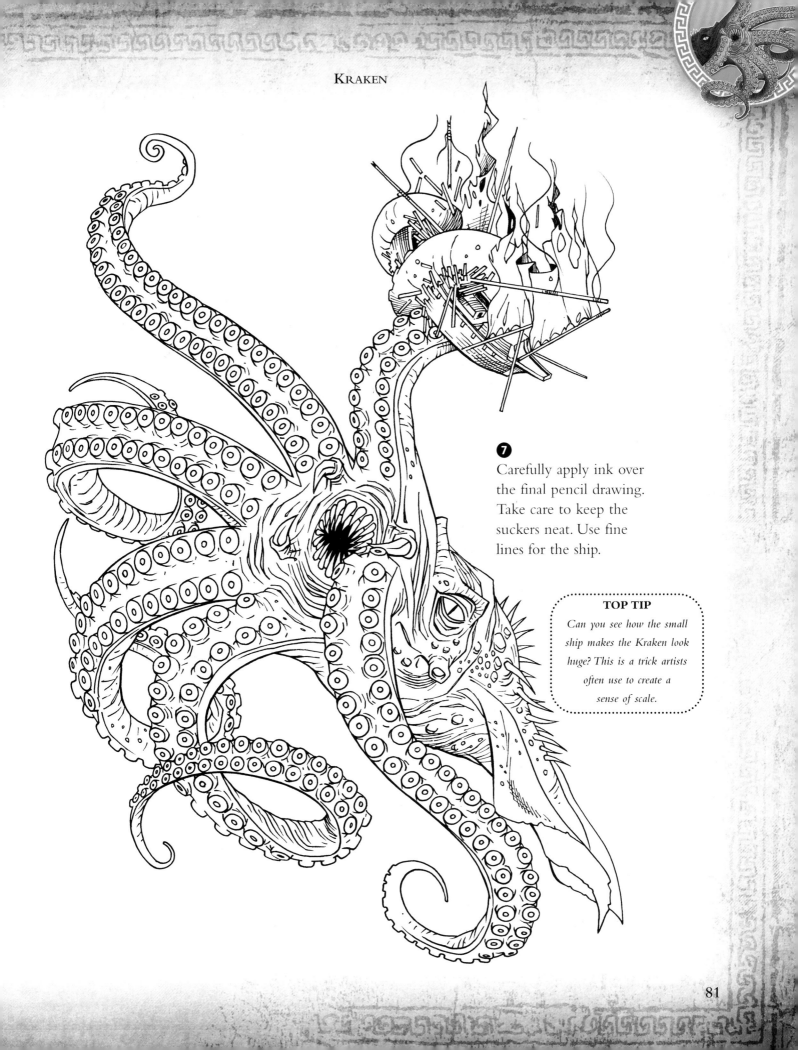

7

Carefully apply ink over the final pencil drawing. Take care to keep the suckers neat. Use fine lines for the ship.

TOP TIP

Can you see how the small ship makes the Kraken look huge? This is a trick artists often use to create a sense of scale.

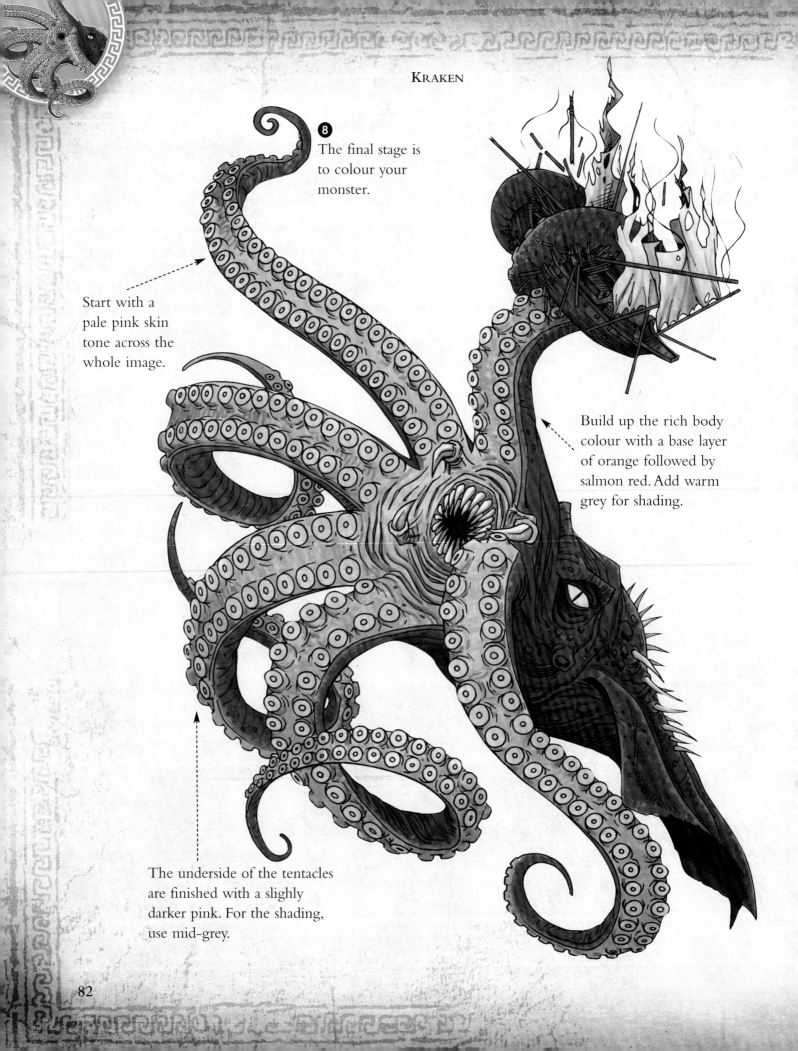

8 The final stage is to colour your monster.

Start with a pale pink skin tone across the whole image.

Build up the rich body colour with a base layer of orange followed by salmon red. Add warm grey for shading.

The underside of the tentacles are finished with a slightly darker pink. For the shading, use mid-grey.

LOCH NESS MONSTER

1

Draw the stick figure. Start with the body and add a long sweeping neck.

2

Build the neck using a row of circles. Include a rectangle for the monster's long snout and triangles for its flippers. Notice how the tail is made up of circles decreasing in size.

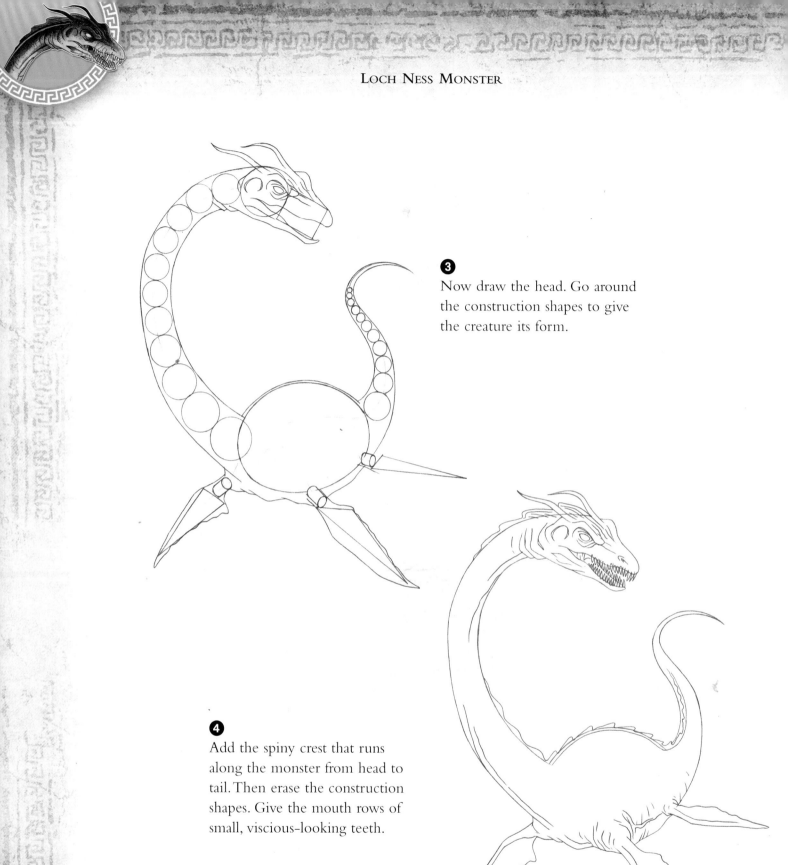

❸ Now draw the head. Go around the construction shapes to give the creature its form.

❹ Add the spiny crest that runs along the monster from head to tail. Then erase the construction shapes. Give the mouth rows of small, viscious-looking teeth.

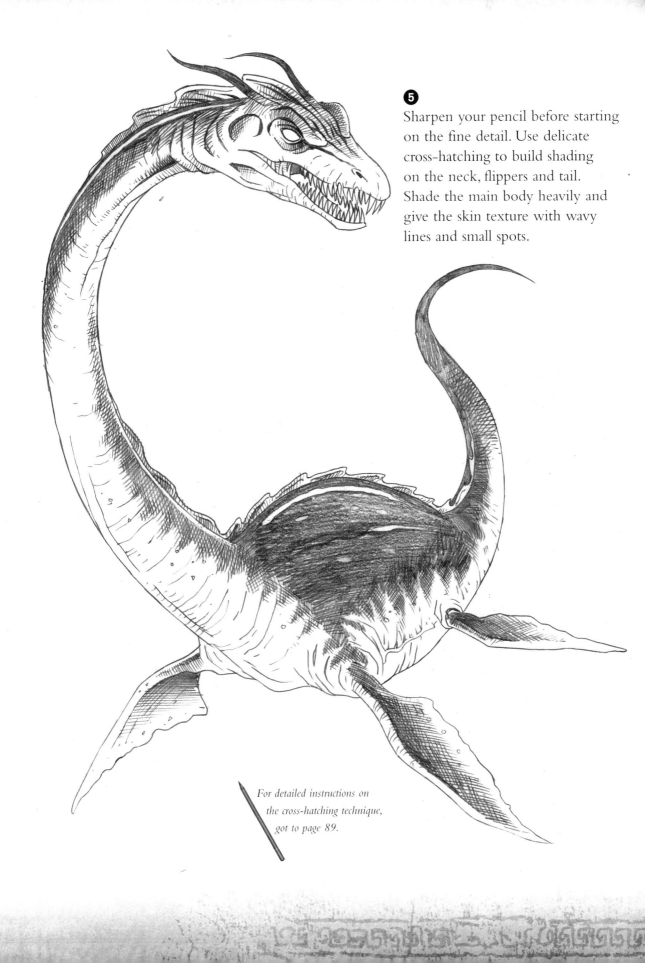

5

Sharpen your pencil before starting on the fine detail. Use delicate cross-hatching to build shading on the neck, flippers and tail. Shade the main body heavily and give the skin texture with wavy lines and small spots.

For detailed instructions on the cross-hatching technique, got to page 89.

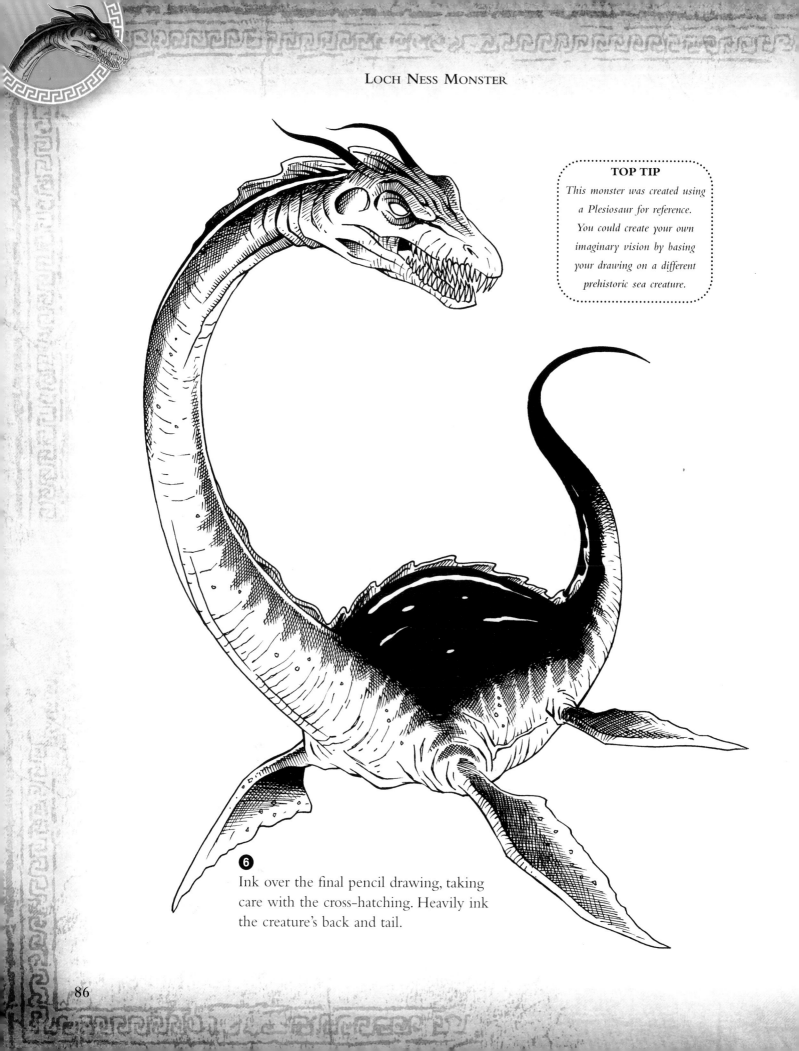

TOP TIP

This monster was created using a Plesiosaur for reference. You could create your own imaginary vision by basing your drawing on a different prehistoric sea creature.

6 Ink over the final pencil drawing, taking care with the cross-hatching. Heavily ink the creature's back and tail.

7

Bring your monster to
life by giving it colour.
Start with a pale grey
base for the skin.

On top of the base, apply
layers of pale ice blue
and aqua blue. Use these
on the face, back of the
neck, spine and tail.

Add military blue
and grey to the
more heavily
inked areas.

Create a dappling
effect on the skin
to add more interest
to the picture.

*Check out page 61
to discover how to
create dappling.*

Triton's face

Triton has a strong face which requires lots of attention to detail. Here is a close-up study to help you complete your drawing of Triton on pages 70–75.

Picture 1 Start with an oval. Then draw lines to roughly work out where the eyes, nose and mouth will sit.

Picture 2 Next add the face. Triton is usually shown as an ancient man. Give him bushy eyebrows and wide features. Include lines on his face to indicate wrinkles.

Picture 3 Next draw his beard. Keep the lines simple and flowing to create a soft shape. At this stage, add the crown too. You need a curved lines for the headband and straight lines to finish it off.

Picture 4 Now add more detail to the crown so it has a definite form and shape.

Picture 5 Clean up the drawing by erasing your construction lines. Give the hair more lines to suggest movement and texture. Drape seaweed around the crown for a fishy feel.

Triton now has the face of a magnificent ancient merman. Your drawing is ready to ink.

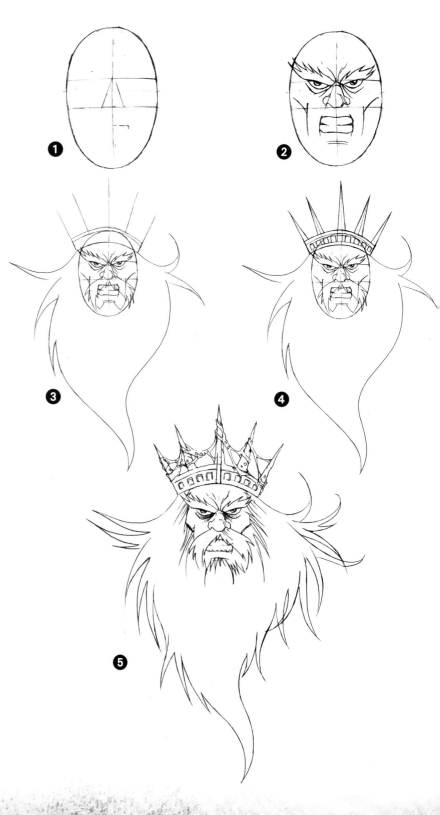

Tentacles

Drawing tentacles involves lots of tricky curves and attention to detail. Follow the tips below to help you draw the squid-like Kraken on pages 76–82.

Picture 1 Start with a simple curved line flowing in any direction you choose. Then add a series of circles decreasing in size.

Picture 2 Next draw the outer layer to create the skin.

Picture 3 After erasing your construction shapes, draw two rows of tightly grouped circles down the length of the tentacle. Draw guidelines across the width to help keep your suckers even.

Picture 4 Rub out your guidelines and finish with fine lines and shading to give the suckers form.

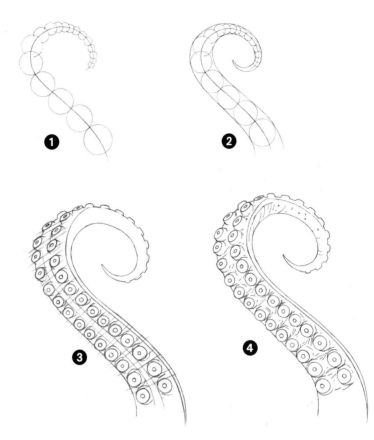

Cross-hatching

Cross-hatching is a method of shading that creates variation in tone. By drawing lines layered one over the other, you can blend from light to dark. This technique is perfect for shading the Loch Ness Monster on page 85.

Start with a series of fine diagonal lines.

Add a row of diagonal lines running in the opposite direction.

Add a row of horizontal lines. Group them tightly at the top and get wider as you work towards the bottom.

WINGED WONDERS

Winged creatures have been the stuff of legend the world over for centuries. **Pegasus**, the winged horse that sprang from the blood of Medusa, was the carrier of brave warriors and adventurers. Less beautiful but highly feared was the **Griffin**, the part-bird, part-lion monster whose ribs were so strong that humans used them as bows. The most terrifying of all the flying creatures was the **Harpy**. Half-woman, half-bird, she was screeching, filthy and was constantly on the lookout for weak and vulnerable prey to slice apart with her long talons.

PEGASUS

1

Start with the stick figure. Draw the horse's body and legs in the correct positions. Include long straight lines for the wings.

 You can learn more about constructing horses on pages 68–69.

2 Next add the construction shapes. The body is one huge cylinder while the legs are a series of different-sized cylinders. The neck is very wide. Remember to draw a rectangle for the long snout.

3 Add the head and draw the horse's face. Make sure the mane and tail hair flick outwards. Give form to the shapes by applying the skin.

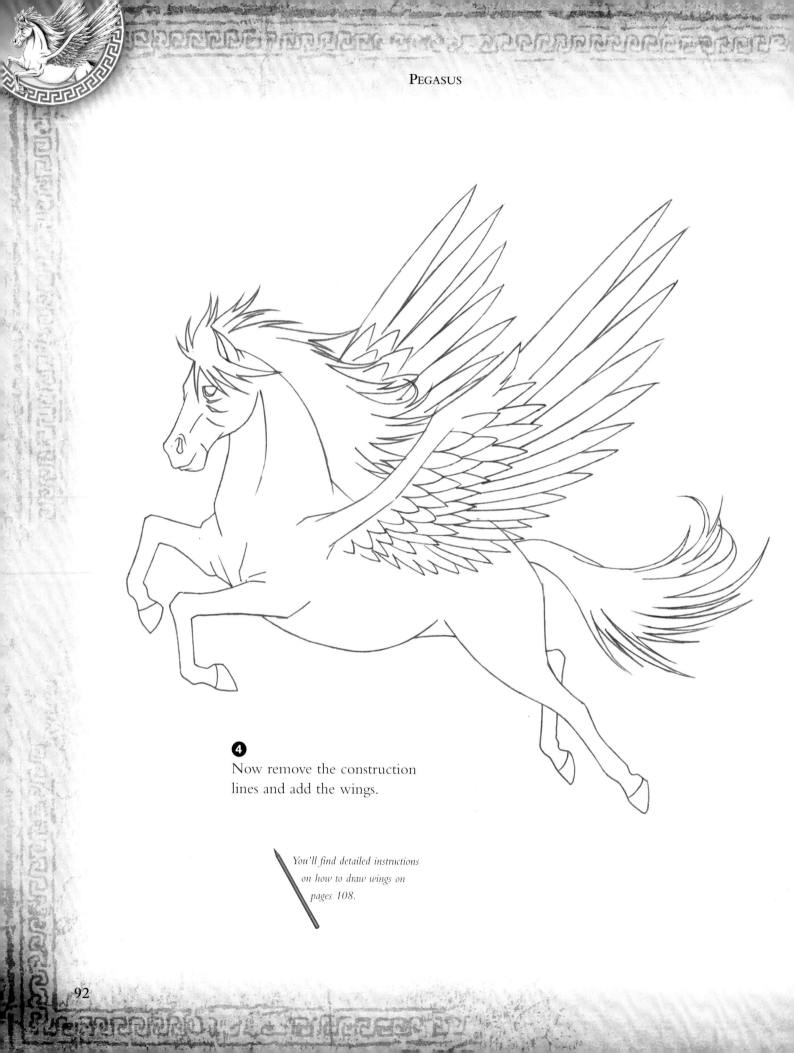

❹

Now remove the construction
lines and add the wings.

*You'll find detailed instructions
on how to draw wings on
pages 108.*

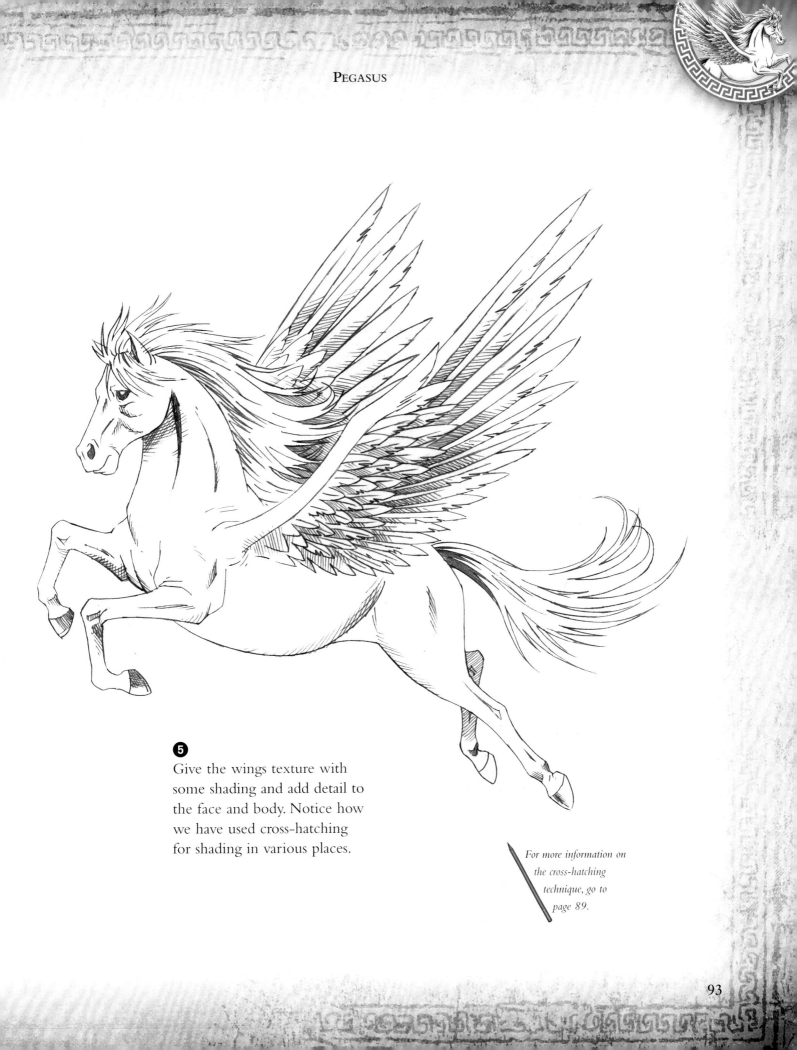

5

Give the wings texture with some shading and add detail to the face and body. Notice how we have used cross-hatching for shading in various places.

For more information on the cross-hatching technique, go to page 89.

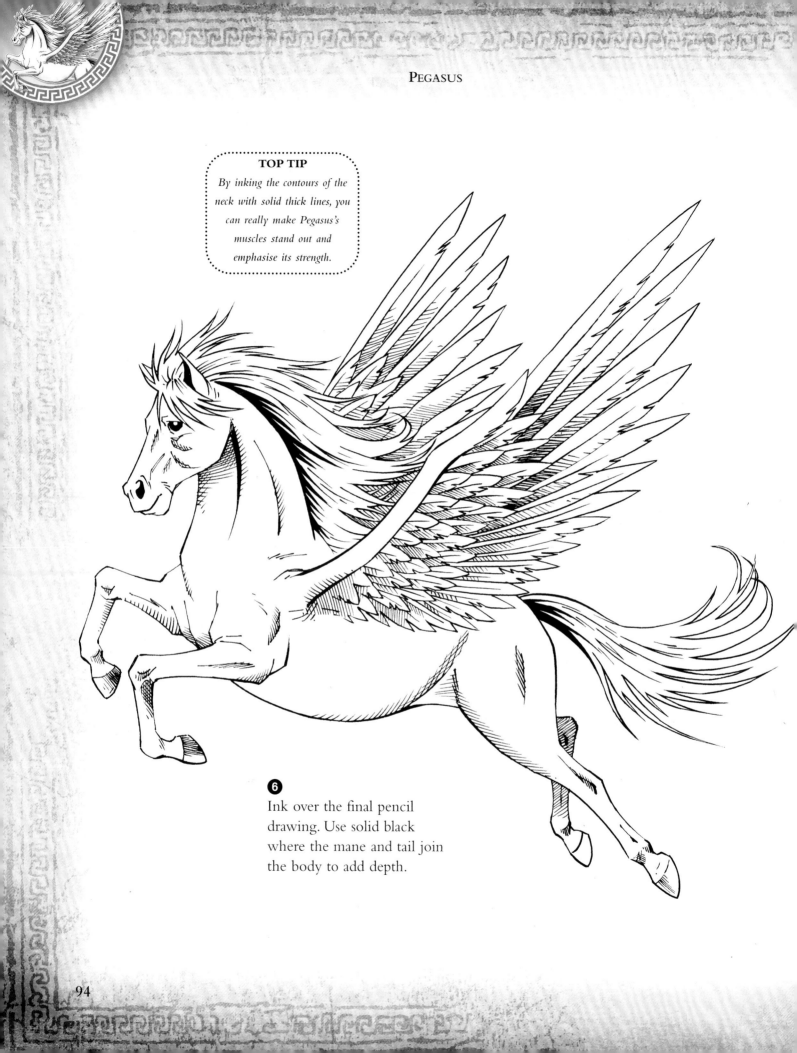

TOP TIP

By inking the contours of the neck with solid thick lines, you can really make Pegasus's muscles stand out and emphasise its strength.

6

Ink over the final pencil drawing. Use solid black where the mane and tail join the body to add depth.

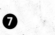

7 Colour this drawing using the palest grey base across the whole image.

When colouring the wings, mane and tail, use darker blue and lilac. Add grey to give definition.

Apply a slightly darker grey to the belly, legs and underside of the neck to create form. Build up the layers with light blue and mauve.

The hooves are grey with hints of mauve.

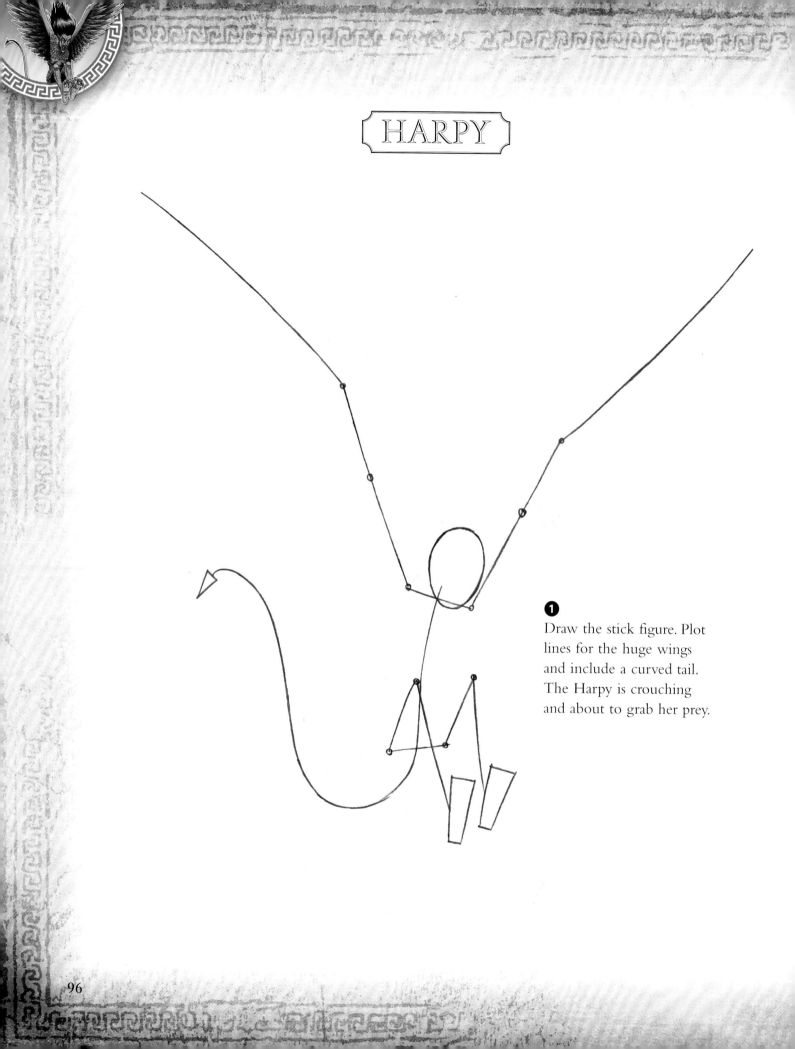

HARPY

1

Draw the stick figure. Plot lines for the huge wings and include a curved tail. The Harpy is crouching and about to grab her prey.

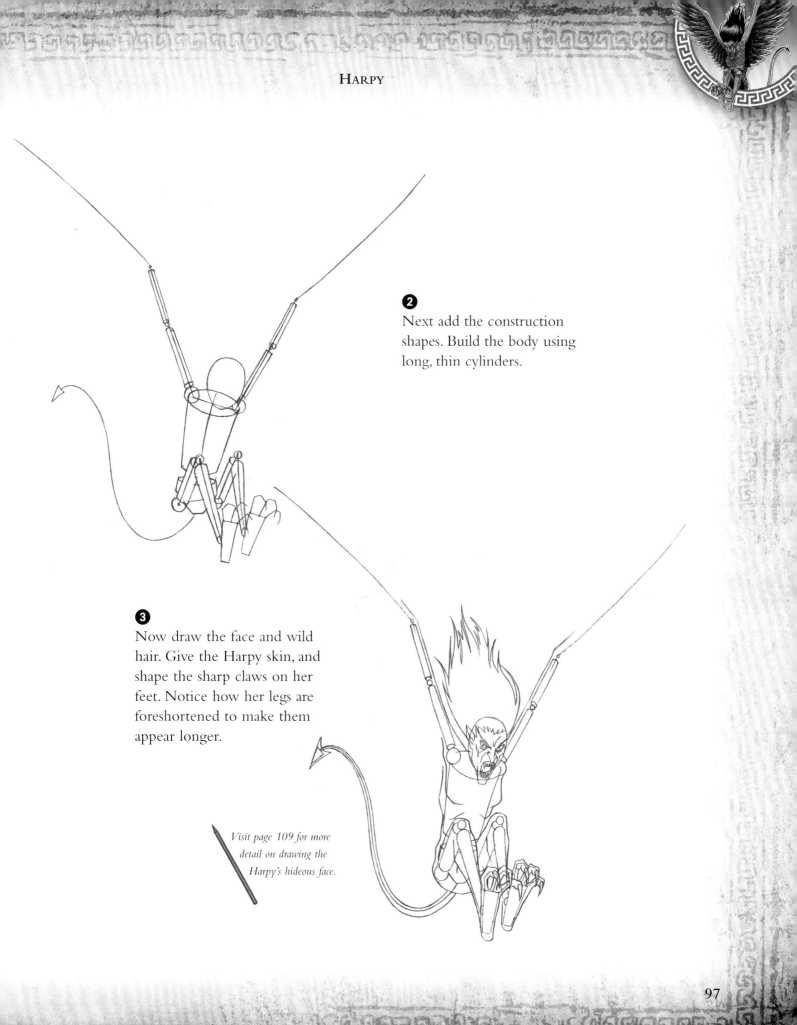

2

Next add the construction shapes. Build the body using long, thin cylinders.

3

Now draw the face and wild hair. Give the Harpy skin, and shape the sharp claws on her feet. Notice how her legs are foreshortened to make them appear longer.

Visit page 109 for more detail on drawing the Harpy's hideous face.

97

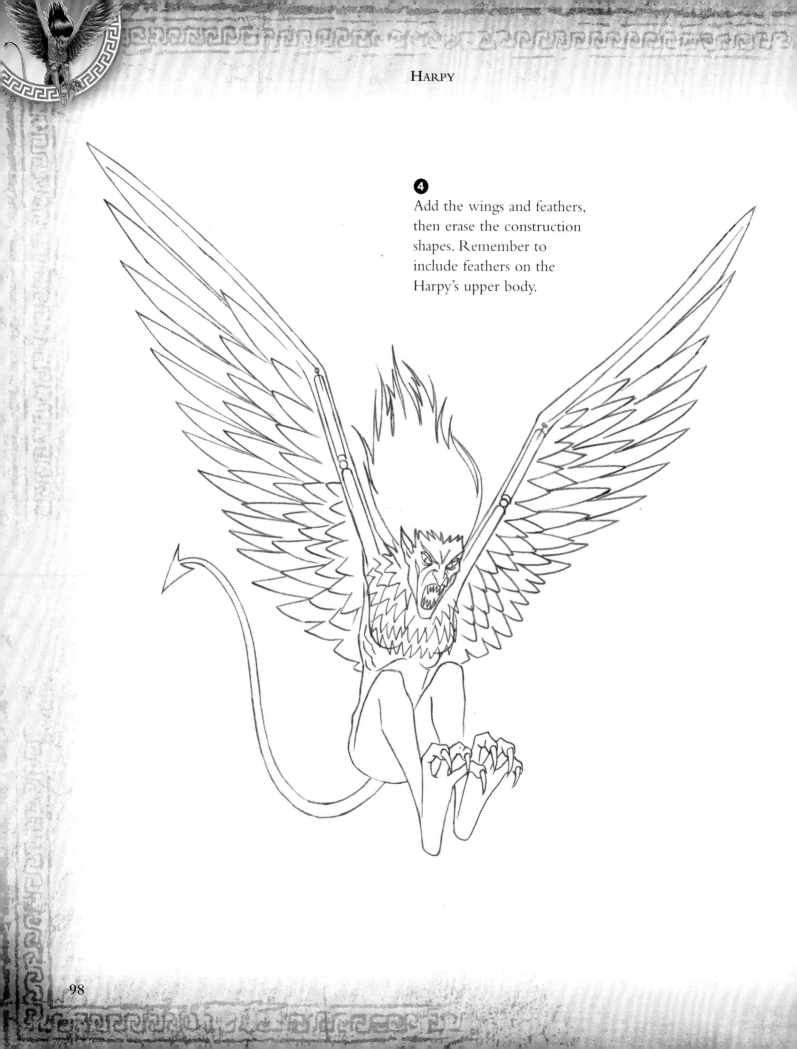

4

Add the wings and feathers, then erase the construction shapes. Remember to include feathers on the Harpy's upper body.

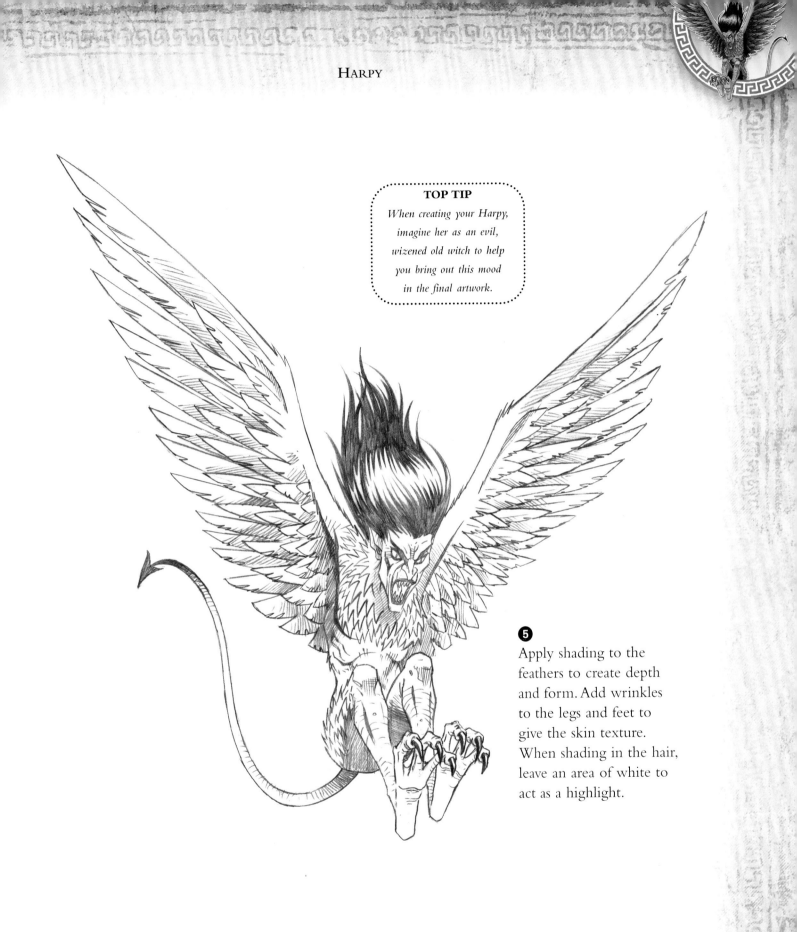

TOP TIP

When creating your Harpy, imagine her as an evil, wizened old witch to help you bring out this mood in the final artwork.

5

Apply shading to the feathers to create depth and form. Add wrinkles to the legs and feet to give the skin texture. When shading in the hair, leave an area of white to act as a highlight.

6

Ink over the pencil drawing, remembering to keep the highlights on the hair and claws. Notice how the solid block of shading behind the Harpy's legs makes her feet leap out of the picture.

7

Colour the evil witch-like Harpy
to make her even more hideous.
Start with a pale yellow-green base.

Build up the feathered
body and wings with
emerald green, darker
green and blue-green.

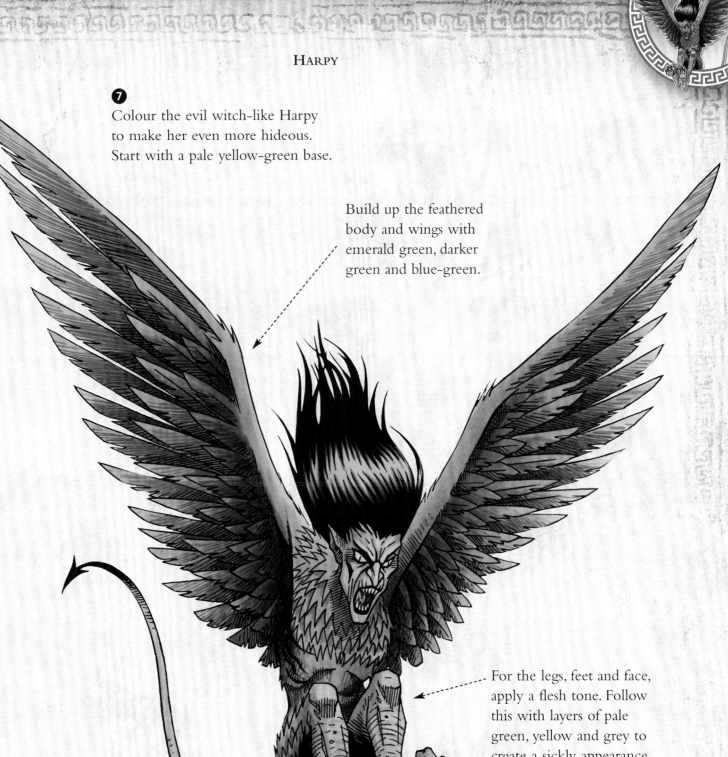

For the legs, feet and face,
apply a flesh tone. Follow
this with layers of pale
green, yellow and grey to
create a sickly appearance.

*For tips on how to draw
the Harpie's face, go
to page 109.*

GRIFFIN

1

Start with the stick figure. Try to draw the line for the spine in one fluid movement. Include two triangles for the Griffin's beak.

2

Next apply the construction shapes using different-sized cylinders. Note that although the Griffin is a winged creature, it has the body of a lion.

3

Now draw the feathered eagle-like head and large beak. Add the skin and flesh out the paws, claws and tail.

TOP TIP

Ensure that the Griffin's beak is hooked at the end, otherwise it might end up looking like the beak of a chicken!

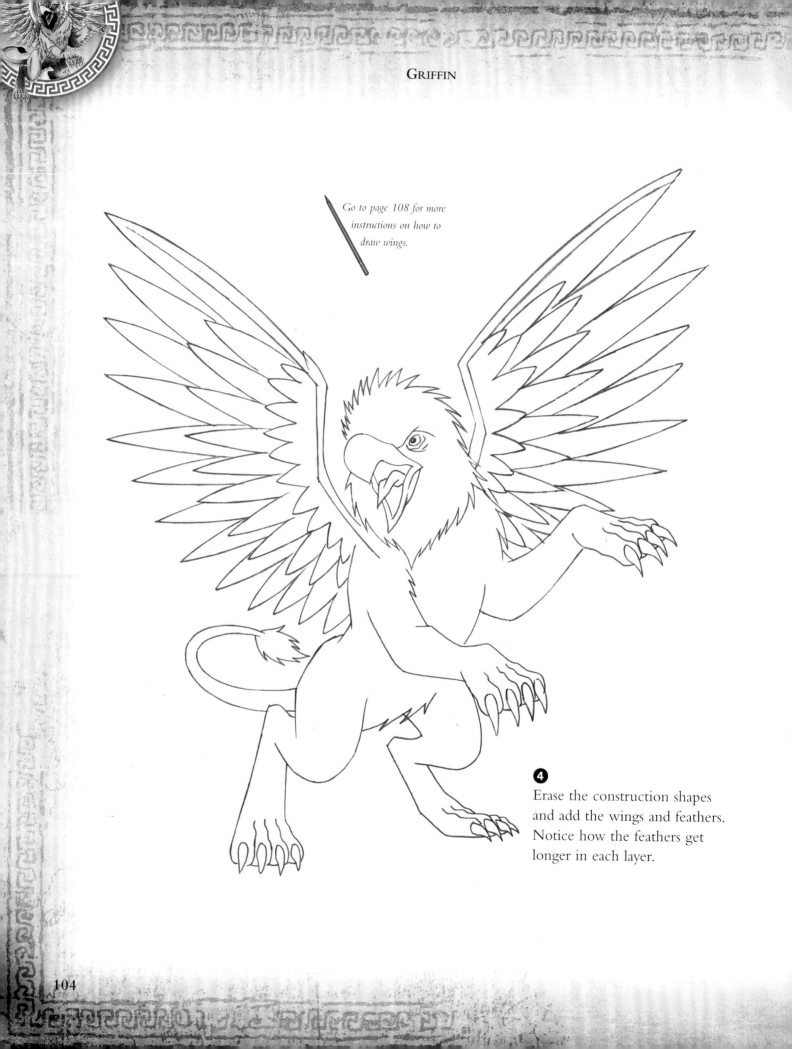

Go to page 108 for more instructions on how to draw wings.

❹
Erase the construction shapes and add the wings and feathers. Notice how the feathers get longer in each layer.

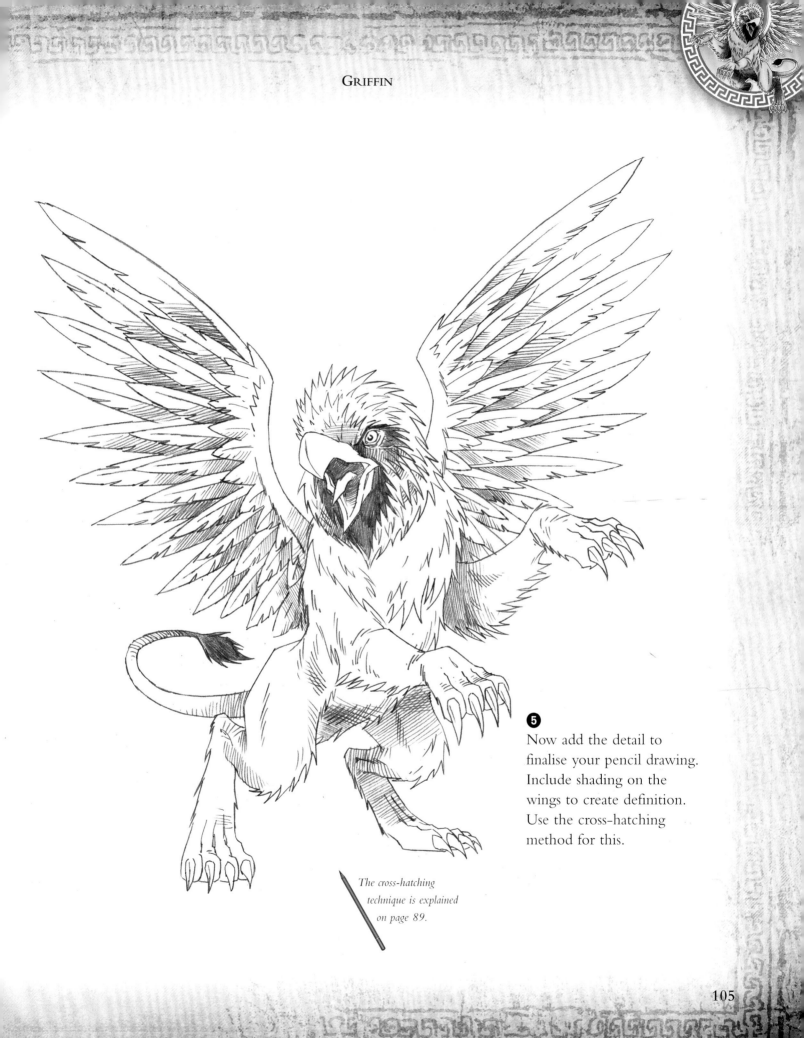

❺ Now add the detail to finalise your pencil drawing. Include shading on the wings to create definition. Use the cross-hatching method for this.

The cross-hatching technique is explained on page 89.

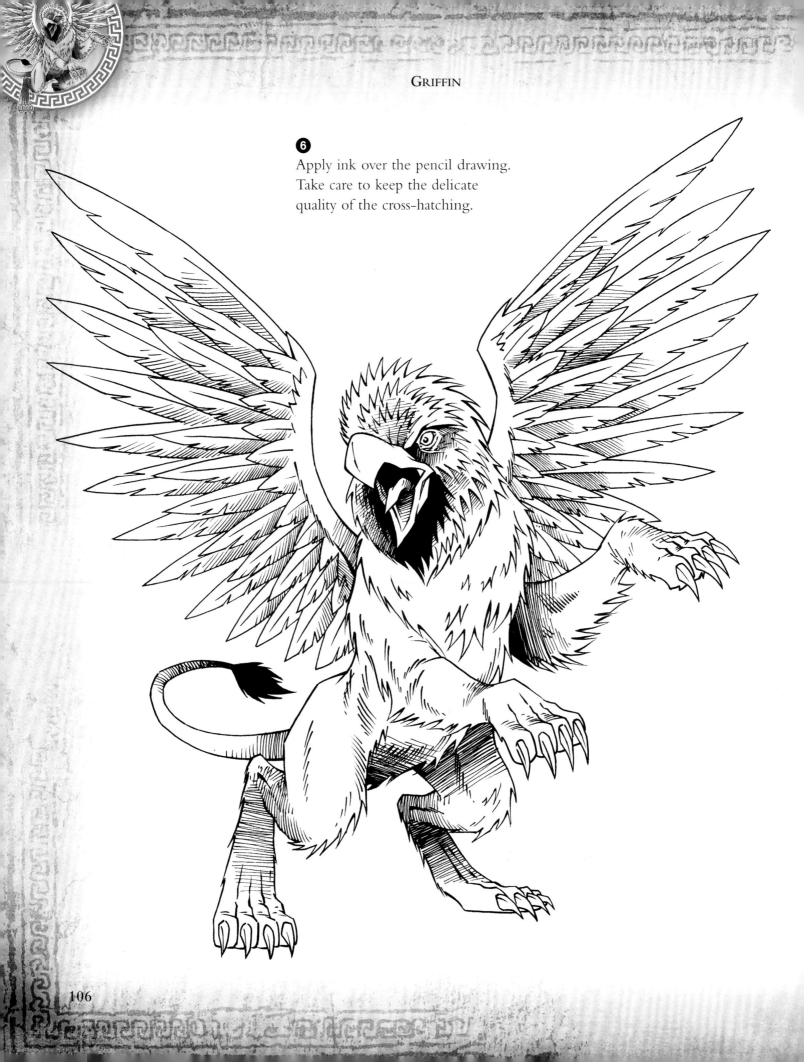

6

Apply ink over the pencil drawing. Take care to keep the delicate quality of the cross-hatching.

7

Your Griffin will look magnificent when you go over it in colour.

Use a light grey base for the head and wings, followed by layers of darker grey with splashes of ice blue. Also add a hint of beige.

Give the beak a yellow base and add orange for the shading.

The lion's body has a sandy beige base. On top of that use a darker sandy tone and light brown.

Drawing Wings

To draw a pair of wings that look credible, it's helpful to study briefly the design of a real bird's wing.

It is not essential to learn the names of the different types of feathers and their purpose (although the more knowledge you have the better), but it is necessary to have a basic understanding of their structure. The diagram below shows the underside of a wing in detail.

Underside of wing

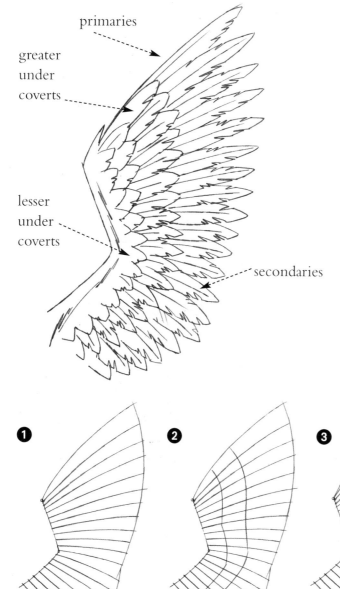

primaries

greater under coverts

lesser under coverts

secondaries

Drawing the wing

Picture 1 As a starting point for drawing a wing, start with a stick drawing that loosely resembles an arm.

Picture 2 Now gauge where the three layers of feathers will sit.

Picture 3 Now add the primary and secondary feathers.

Picture 4 Now draw the coverts. Finally add some detail and now you have a wing that's ready to ink.

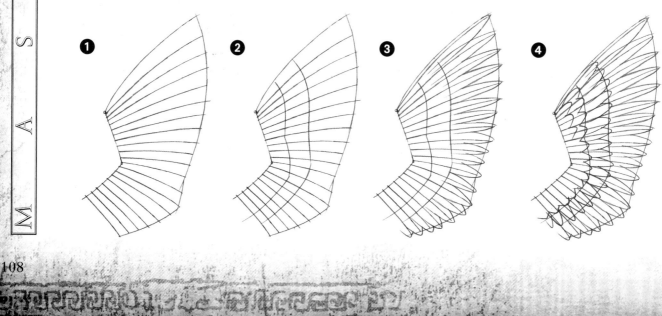

Harpy's face

Here we'll give more detail on constructing the head of Harpy from page 97.

Picture 1 Construct the head of the Harpy.

Picture 2 Draw the features of the face. Note the large thin hook nose that is almost beak like and the pointy cheek bones.

Picture 3 Add the shape of the hair, which is almost like that of a wobbly tear drop. It is best to start with a simple, uncomplicated shape to establish the flow of the hair.

Picture 4 Now add detail to the hair, teeth and mouth.

Picture 5 Finally, shade in the hair and face and the Harpy's head is complete.

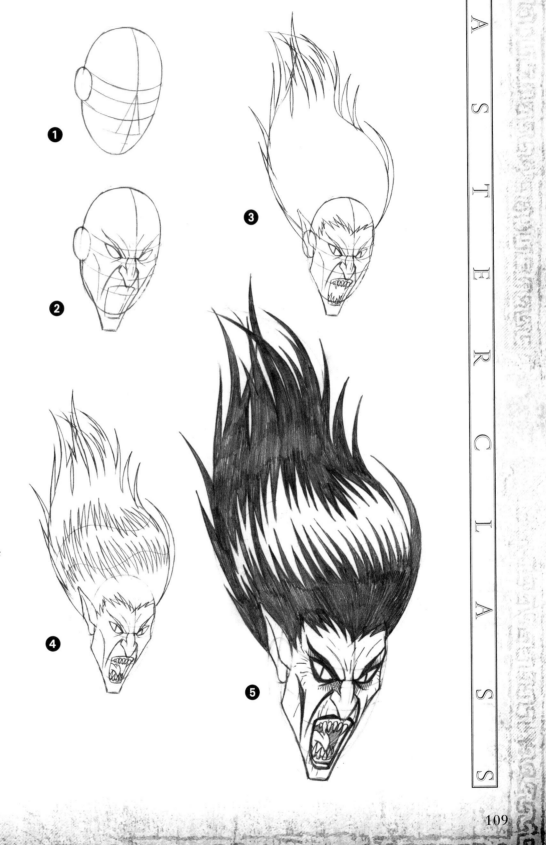

THE CURSED

Eastern Europe's most infamous folkloric beast, the **Vampire**, has a name as old as its myth – 'vampir' from the Hungarian word for witch. These deadly shape shifters changed from humans into bats and were thought to sleep in coffins. Similarly cursed was the **Werewolf**, who for centuries prowled lands from Brazil to Russia, but only on a full moon and always when thirsty for blood. The **Zombie** is rumoured to exist along the Caribbean coast even today. Sorcerers apparently have slaves under their control, their eyes white, their faces dead, but their bodies still very much alive.

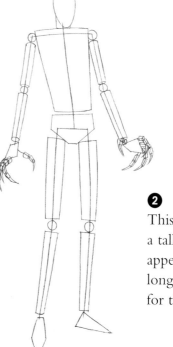

VAMPIRE

1

Start with the tall stick figure.

2

This creature needs a tall, nightmarish appearance, so add long, cylindrical shapes for the arms and legs.

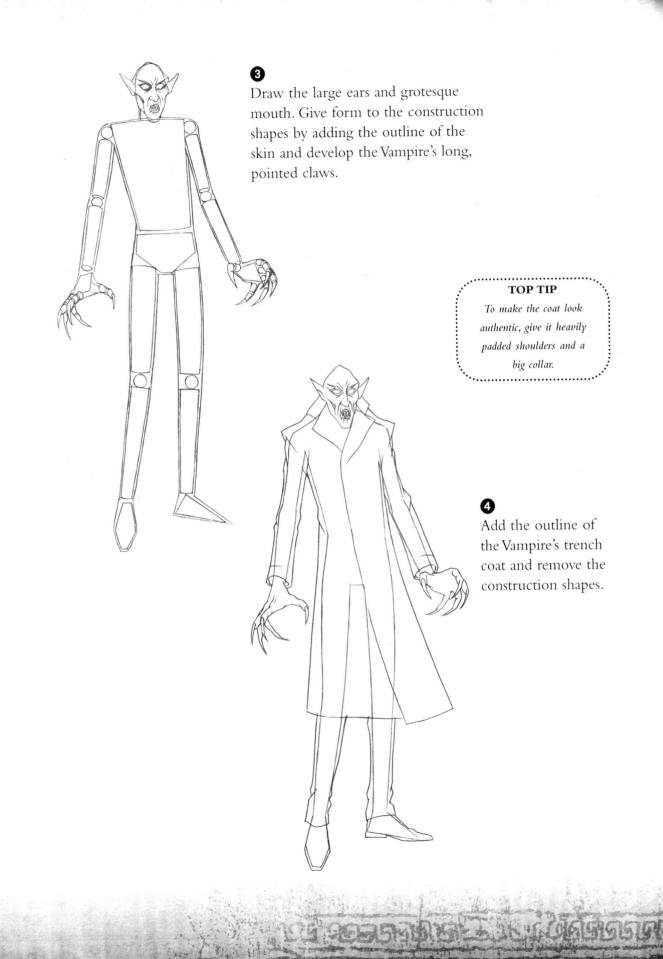

3

Draw the large ears and grotesque mouth. Give form to the construction shapes by adding the outline of the skin and develop the Vampire's long, pointed claws.

TOP TIP

To make the coat look authentic, give it heavily padded shoulders and a big collar.

4

Add the outline of the Vampire's trench coat and remove the construction shapes.

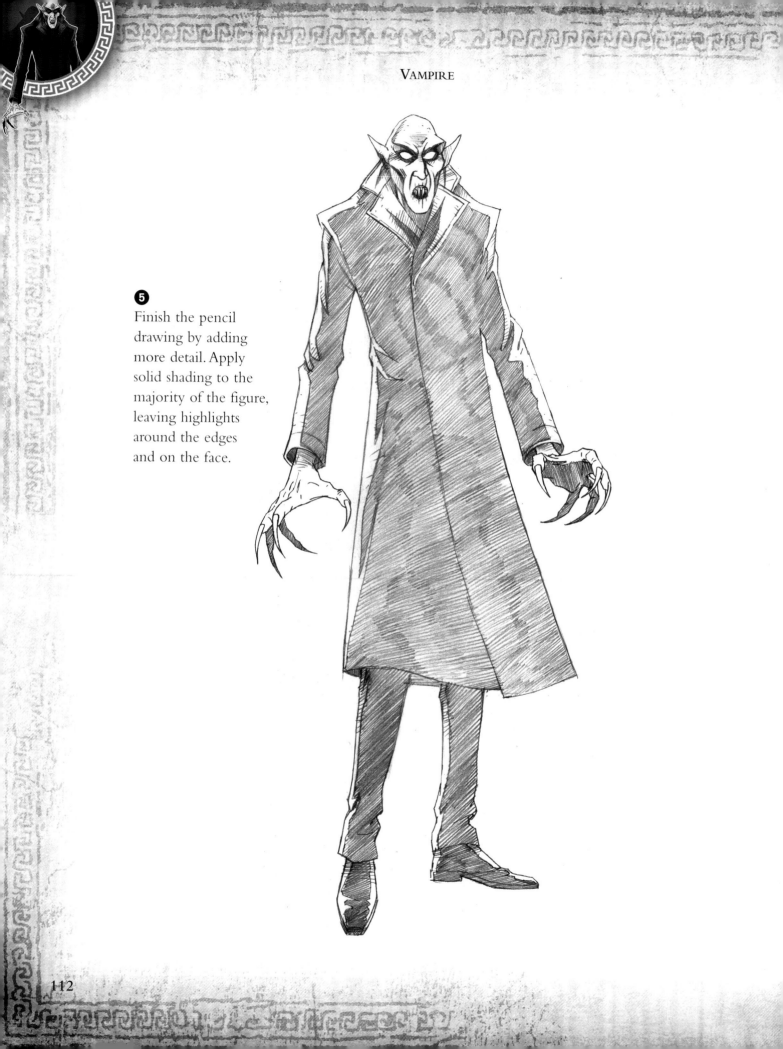

❺
Finish the pencil drawing by adding more detail. Apply solid shading to the majority of the figure, leaving highlights around the edges and on the face.

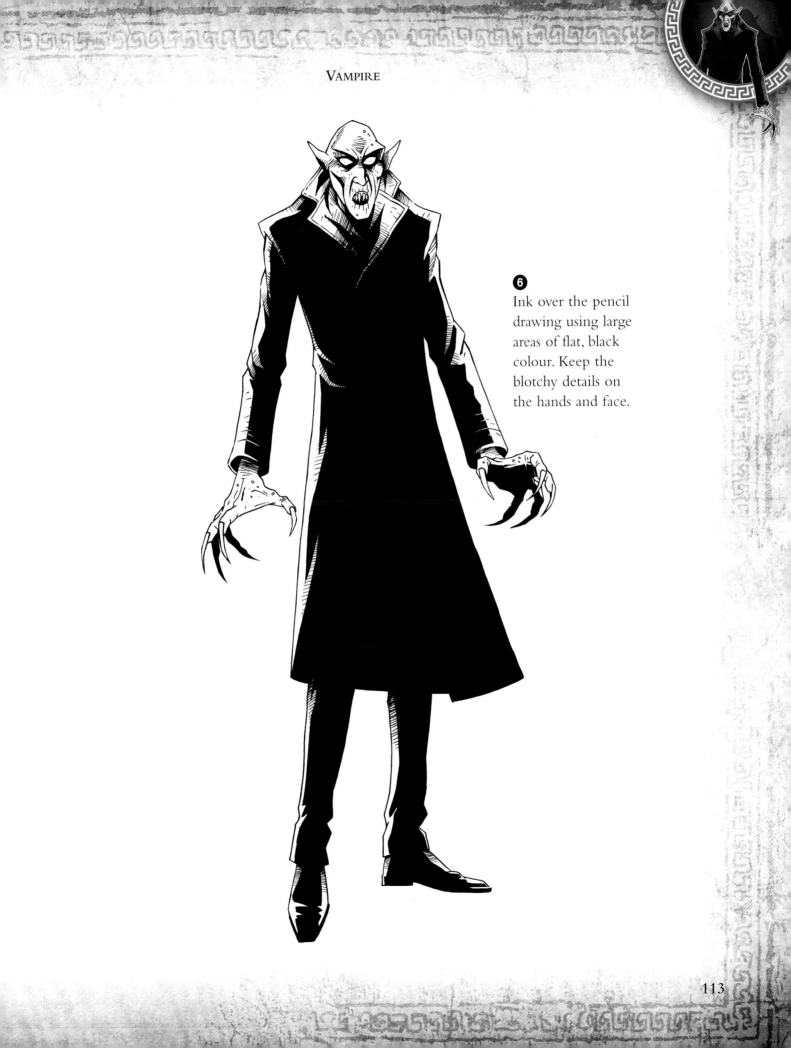

6
Ink over the pencil drawing using large areas of flat, black colour. Keep the blotchy details on the hands and face.

7

When colouring the Vampire avoid using warm skin tones. Keep to pale greys and yellowy greens to create a ghoulish look.

Create darker areas around the eyes and finish off the face by making the eyes blood red.

Colour the coat using a mid-grey base followed by layers of dark blue.

WEREWOLF

1

Draw the stick figure in a threatening pose.

2

Construct the upper body using solid cuboids. Use cylinders for the arms and legs, drawing larger ones for the upper legs, which are broad.

❸ Draw the face and the outline of the skin around the construction shapes. Note that the head is like that of a human but with animal features.

❹ Erase your construction shapes and add detail. Give the creature torn clothes as evidence of his violent transformations. Add claws and give his body fur.

TOP TIP

When drawing the hair, don't draw every strand – use well placed lines to create the appearance of hair instead.

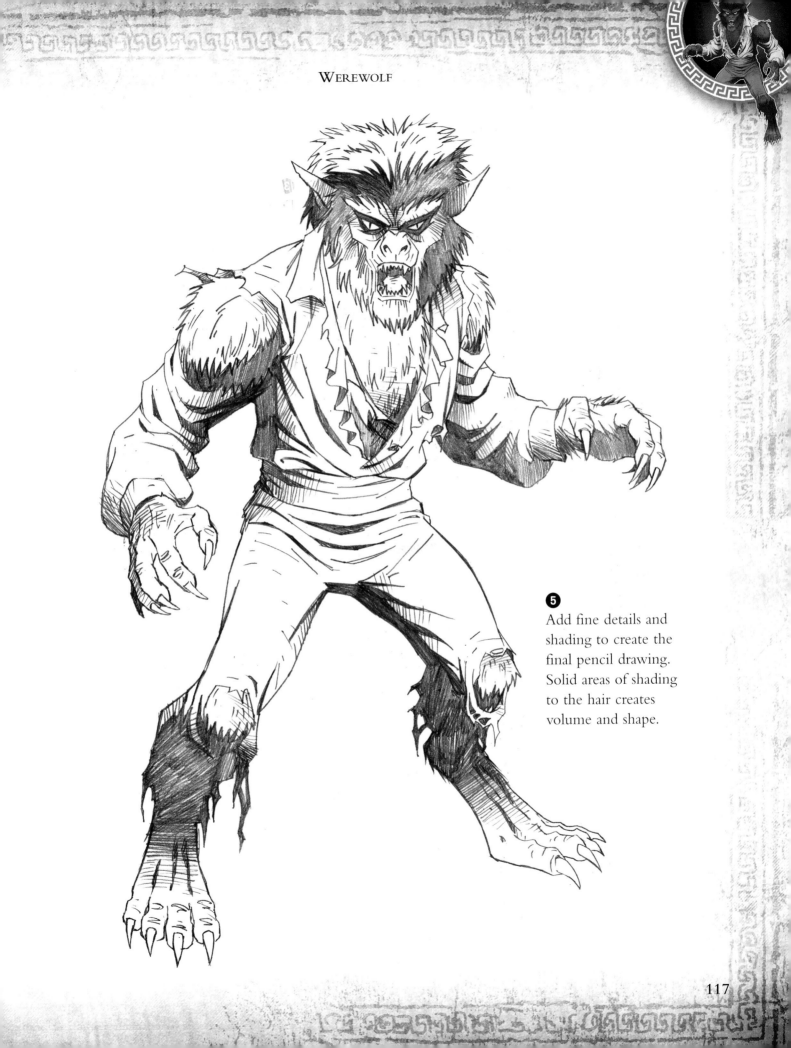

5 Add fine details and shading to create the final pencil drawing. Solid areas of shading to the hair creates volume and shape.

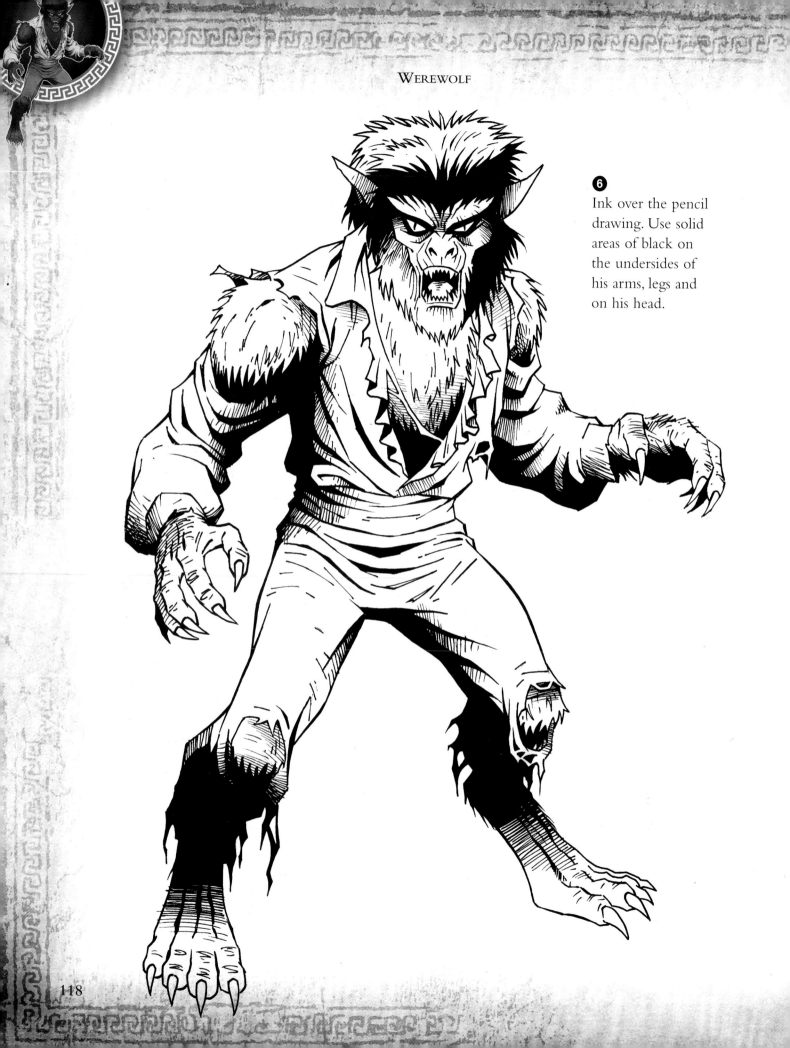

6

Ink over the pencil drawing. Use solid areas of black on the undersides of his arms, legs and on his head.

7

It's time to colour your Werewolf which will really bring him to life.

Colour the fur using a mid-brown base and build up with darker layers of red-browns. Blend in the darker areas using dark greys.

Colour the shirt using very pale greys as a base, followed by layers of darker greys to create shaded areas. Use an olive green to colour the torn trousers. The claws are coloured using a blend of greys and navy blue.

Use the dappling effect for the blood stains. See page 61 for further details.

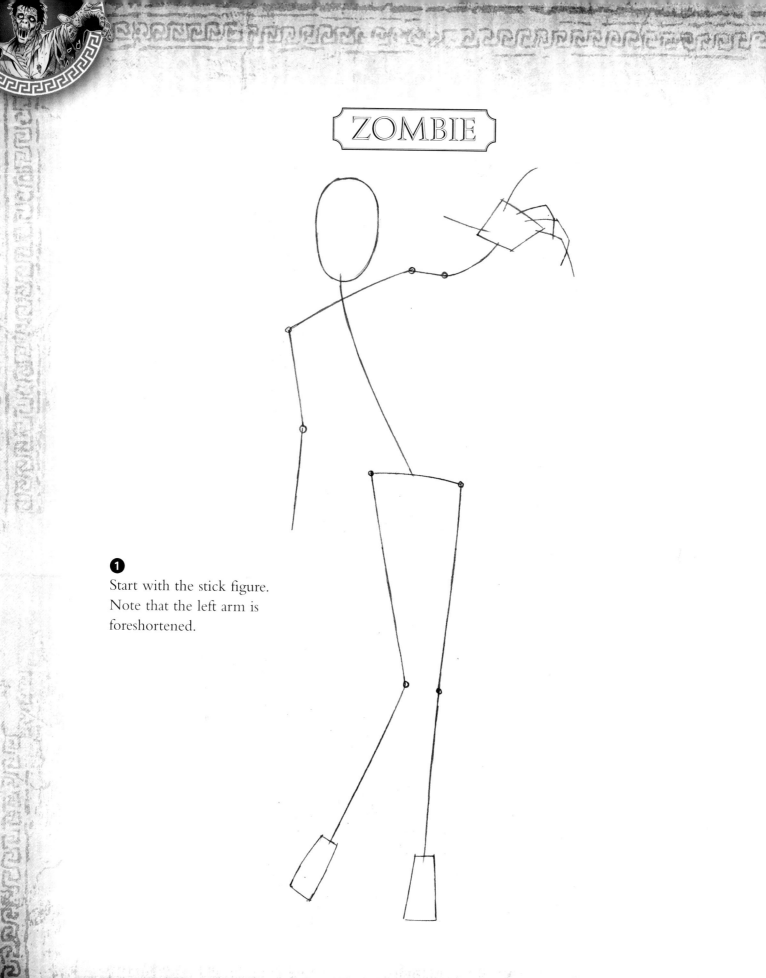

1

Start with the stick figure.
Note that the left arm is
foreshortened.

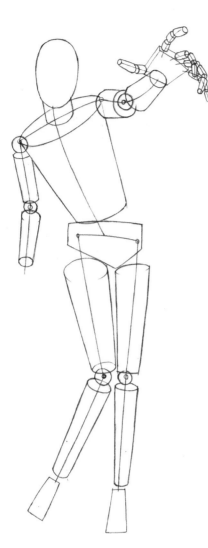

2

Now apply the cylindrical construction shapes. Short, fat cylinders are used on the left arm.

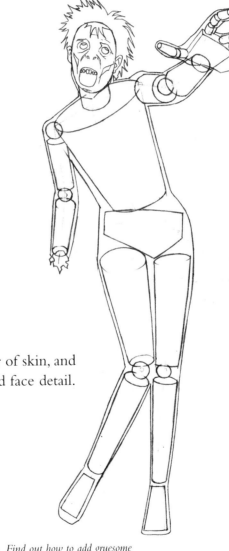

3

Add a layer of skin, and the hair and face detail.

Find out how to add gruesome detail to the Zombie's face on page 127.

TOP TIP

The Zombie has the face of someone who is 'undead'. The eyes are sunken and dark, and all fluid has drained from the skin so it appears wrinkled. The teeth can be rotten, too.

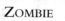

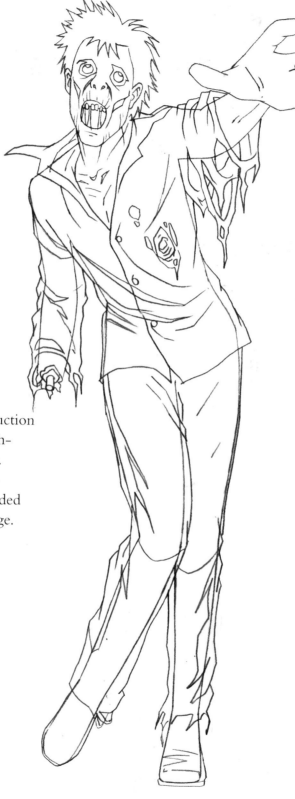

4

Remove the construction shapes and add moth-eaten, tatty clothing. The outfit is basic – the detail will be added in the colouring stage.

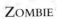

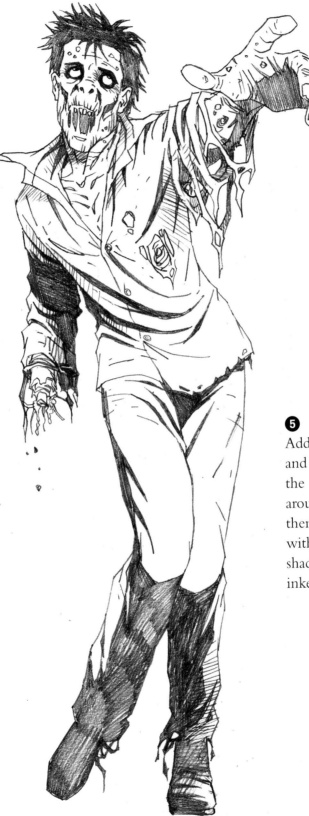

5

Add wrinkles to the face and darken the area around the eyes. Add shading around the cheeks to make them look sunken. Finish with some block areas of shading that will be solidly inked over.

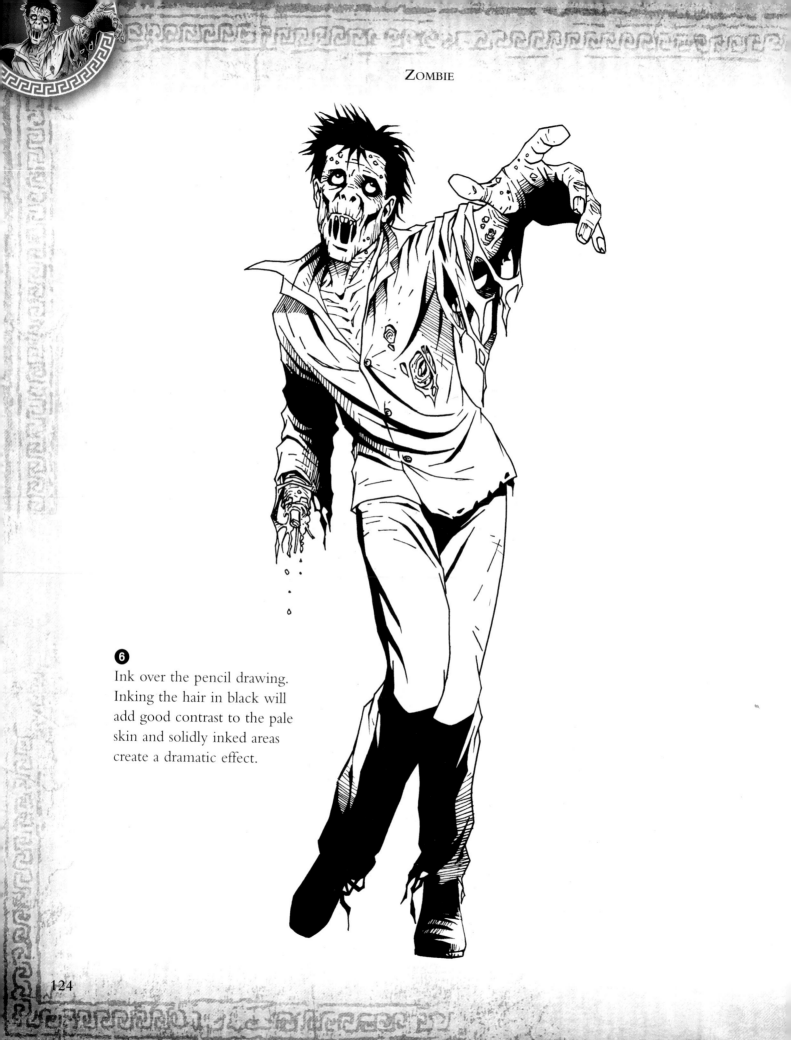

6

Ink over the pencil drawing. Inking the hair in black will add good contrast to the pale skin and solidly inked areas create a dramatic effect.

Zombie

7 Colour the Zombie, adding some gruesome colour effects.

The skin should look lifeless, so keep to very pale (almost white) skin tones. Build up with layers of very pale grey and light greens.

Colour the shirt in white, then add blotchy red blood stains. Colour his trousers using layers of dark grey.

Use the dappling effect for the blood stains. See page 61 for further details.

TOP TIP

Creating an aged, washed-out look is easy. If you are using coloured markers, use a wet blender marker and daub the ink over the dried colours. This will disperse the pigment in the ink and give a washed out appearance. If you are using watercolours, load your brush with clear water and apply unevenly over the dried watercolour paint. Once this has dried, go over the drawing re-establishing darker areas that may have been lost during the bleaching session.

Evil Hands

Here we will look at how you can transform a drawing of a human hand into that of a monster, by simply thickening or thinning the shape.

The pictures below show the basic construction of a human hand.

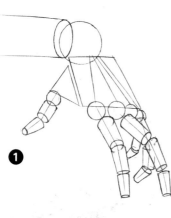

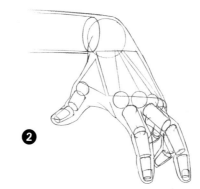

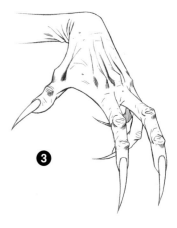

Picture 1 By thickening the palm and the digits and adding hair and claws you can transform the human hand into that of a werewolf (see below).

Picture 2 By thinning the overall shape and adding long, narrow nails, the had begins to take on the appearance of a vampire's (below).

Picture 3 You can exaggerate the shape of the hand, fingers and nails to create a more nightmarish version (below).

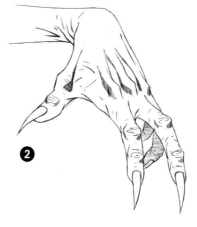

Beastly Heads

Let's take a closer look at drawing the head of the zombie found on page 121.

Picture 1 Start with the basic oval shape for the head and map out the grid for the eyes, nose and mouth.

Picture 2 Draw in the features. The eyes are sunken, the nose has collapsed and the skin is streched tight across the skull.

Picture 3 Define the jaw line and add the teeth and unkempt hair.

Picture 4 Now add shading and detail to the skin. Notice the dark shading around the eyes to create that sunken look, and the tightening of the skin around the cheekbones and mouth.

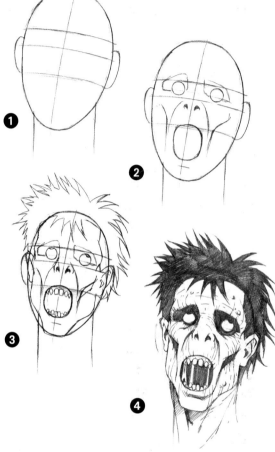

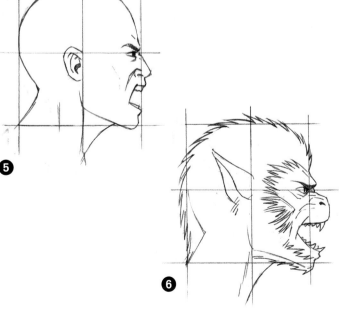

Picture 5 shows a profile of a human head. In **Picture 6** the human head has been distorted and transformed into a beast. Notice how the brow, and the nose and mouth areas have been extended for an animalistic effect.

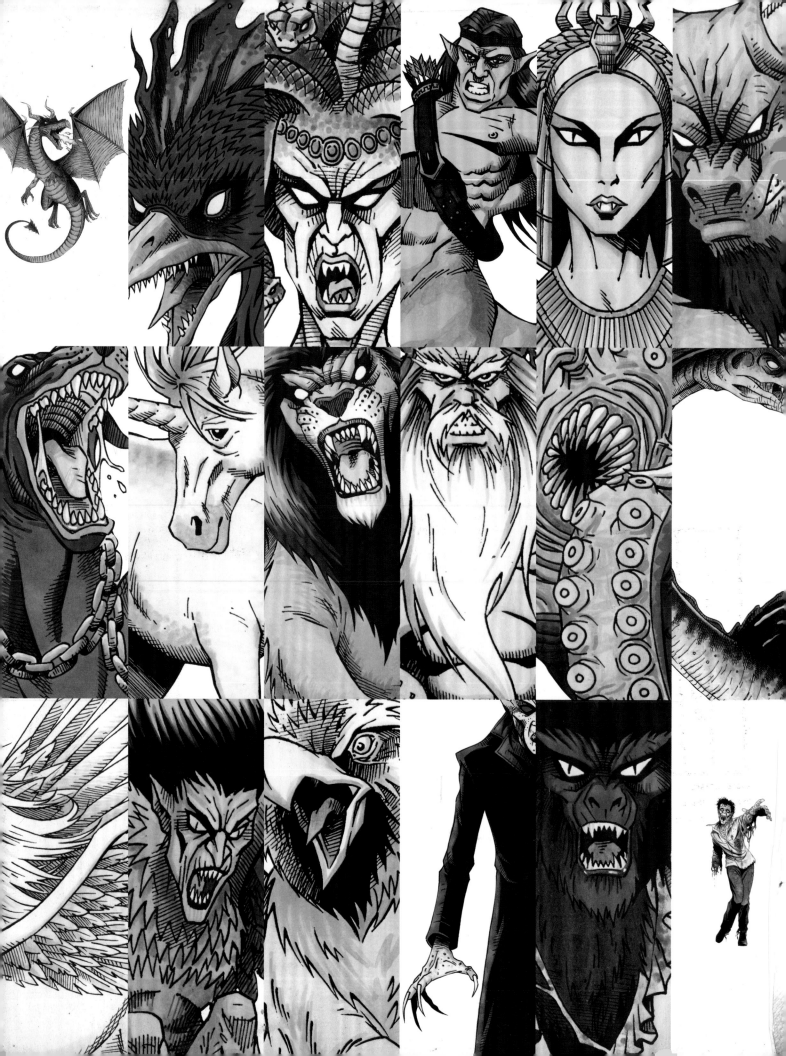